The Winning Ways of Watercolor

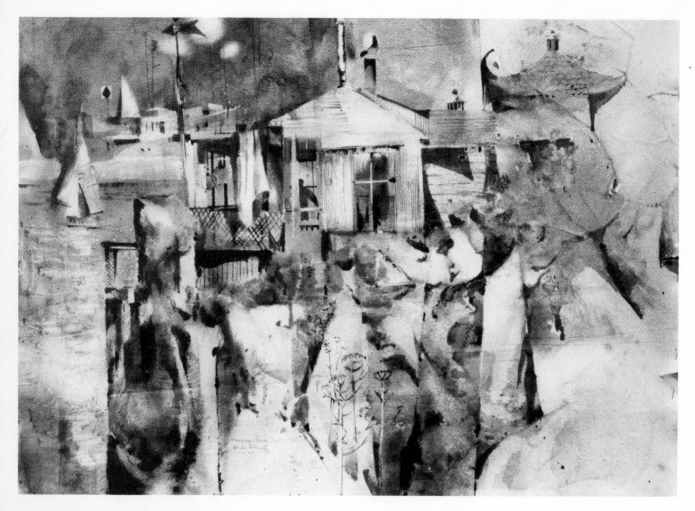

MORNING: ROCKY POINT, 21″ x 29″

Collection Helen H. Zillgitt

The Samuel F. B. Morse Medal, National Academy of Design, 1968. The Lily Saportas Award, American Watercolor Society, 1968.

The Winning Ways of Watercolor

Rex Brandt

BASIC TECHNIQUES AND METHODS
OF TRANSPARENT WATERCOLOR
IN TWENTY LESSONS

VNR VAN NOSTRAND REINHOLD COMPANY
New York Cincinnati Toronto London Melbourne

Books by the artist

WATERCOLOR WITH REX BRANDT, 1949
WATERCOLOR TECHNIQUE IN 15 LESSONS,
previous editions 1950, 52, 54, 56; 6th edition 1963
WATERCOLOR LANDSCAPE IN 15 LESSONS, 1953
THE COMPOSITION OF LANDSCAPE PAINTING, 1959
WATERCOLOR LANDSCAPE, 1963
THE ARTIST'S SKETCHBOOK AND ITS USES, 1966
SAN DIEGO, LAND OF THE SUNDOWN SEA, 1969
REX BRANDT: A PORTFOLIO OF RECENT WORKS, 1972
THE WINNING WAYS OF WATERCOLOR, 1973

Van Nostrand Reinhold Company Regional Offices:
New York Cincinnati Chicago Millbrae Dallas
Van Nostrand Reinhold Company International Offices:
London Toronto Melbourne

Copyright © 1973 by Litton Educational Publishing, Inc.
Library of Congress Catalog Number 72-1438
ISBN 0-442-21404-9

Printed by Halliday Lithograph Corporation
Color printed by Princeton Polychrome Press
Typography by O. Leventhal, Inc.
Bound by The Book Press

Published by Van Nostrand Reinhold Company
450 West 33rd Street, New York, N.Y. 10001
Published simultaneously in Canada by
Van Nostrand Reinhold Limited
16 15 14 13 12 11 10 9 8 7 6 5 4 3 2 1

The author and Van Nostrand Reinhold Company have taken
all possible care to trace the ownership of every work of art
reproduced in this book and to make full acknowledgment
for its use. If any errors have accidentally occurred, they will be
corrected in subsequent editions, provided notification is
sent to the publisher.

SEASCAPE, John Marin Collection Los Angeles County Museum of Art

ACKNOWLEDGMENTS

It started more than thirty years ago as a mimeographed answer sheet for students in my college painting classes. After the war it was expanded to a pocket-size printed booklet for the watercolor students at Chouinard Art Institute and at our Summer School at Newport Harbor. Finally, retitled "Watercolor Technique," it went through six editions, over 40,000 copies. I have now revised it completely and augmented it with sections from my other books on composition and sketching — but this present book remains, I hope, as at the beginning, an answer to the challenging questions presented by eager students.

You have created the book through your questions and through the discoveries and the information you have shared with me. I think this is a good time to say thank you!

In addition, I express my gratitude to the following:

The museums, galleries, publications, as well as my dealers and their photographers, who have all generously made new material available;

My fellow watercolorists who have permitted me to reproduce their works;

Mr. Charles Shelton of Best-West Publications for permission to reproduce examples from *Rex Brandt's San Diego, Land of the Sundown Sea;* and Mr. James Killingsworth, publisher of *Orange County Illustrated,* for permission to use color examples that first appeared in his magazine;

My wife, artist Joan Irving, for her contributions to the manuscript and the art copy.

COLOR ILLUSTRATIONS

CONTENTS

Architectural rendering for William Blurock, Architect

FOREWORD

I am an artist.

I sell shapes and colors.

I deliver most of my shapes and colors on paper — floating pigments into place with water — because transparent watercolor glows like stained glass and reproduces like a dream.

When the water evaporates and the gum binder takes hold, each trailing wisp and nuance is bound to the white surface. This is watercolor — one of the oldest mediums known to man.

These lessons explore its *winning ways*, dividing that investigation into two parts: The technical characteristics of paint, water, and paper first; then the procedures or *ways* by which the painter employs these techniques to make paintings.

If you will follow the twenty lessons step-by-step, I can assure you that the eloquence and directness of watercolor will be yours; and those mysterious "difficulties of the medium" will be surmounted.

What use you make of this accomplishment is up to you. It is a versatile medium and can be employed for purposes ranging from sketches to exhibition paintings.

As an introduction I have selected three examples from my own work, which utilize watercolor for divergent goals. Each is a product of the same round Allman palette and handful of brushes and pigments.

I. Watercolor can represent things as we SEE them
Watercolor is a perfect medium for the sketch, quick color note, or on-the-scene record. It has been the darling of travelers since the time of Albrecht Dürer in sixteenth century Germany and of the Tang Dynasty painters in China, A.D. 618-906.

Because it reproduces well, it is a favorite medium for illustration, both for the publishing trades and for architects and engineers in their visualization of plans.

II. Watercolor can convey FEELINGS about things
As an interpretive medium its poetic possibilities are unrivalled, augmenting the personal and subjective qualities of drawing with color. It is especially descriptive in suggesting the moods of the outdoors.

The travel posters for American Airlines opposite are an example of a typical interpretation assignment.

BIG PEPPER, 19″ x 29″ Collection Mr. and Mrs. Robert E. Wood

First Award, 50th Annual Exhibition of the California
National Watercolor Society, 1971

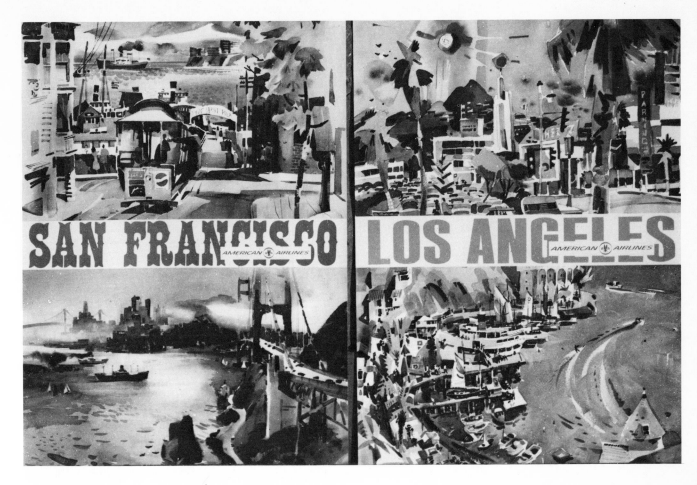

Travel posters for American Airlines

III. Watercolor can be beautiful as an object
The way thin color on white paper reflects light is comparable to the luster
of a sea shell, the translucence of a tide pool, the luminosity of colored glass
against the sun.

Awareness of this unique quality can elevate such a modest medium to
greatness, as is exemplified in the luminous aquarelles of Turner, Cézanne,
Sargent, Marin, and others.

In recent years, as I become a little less baffled by the problems of represen-
tation and interpretation, my awareness of the inherent beauty of transparent
pigment on white paper has increased. The painting on the facing page,
titled BIG PEPPER, is an example.

If you are concerned that you have not yet discovered what it is you want
to do with paint, don't worry. Paint a while. Get to know watercolor and it
will show you a way.

Rex Brandt
Blue Sky
Corona del Mar
California

INTRODUCTION

ARTIST AS STUDENT

When as a boy of 13 I first attended classes at Chouinard Art Institute, my goal was very simple — to make pencil drawings of things as I saw them.

It was a number of years before I achieved this, but in the meantime something had happened. I found a new goal. It was to translate what I saw to a sort of quick sketch; and before that ability was mastered, new challenges presented themselves.

So it goes, like a horse following the apple on a string, our expectations precede us. We look back and say, "I have mastered that"; then, almost as an axiom, we look forward to new discoveries and achievements.

There are no absolutes in painting. All is measured by that relative term *quality*. It is in this search for quality that the artist is, of necessity, the eternal student.

I make the above observation to discourage what has become a rather unhappy situation in art today: the tendency to start where the other fellow left off, rather than at the beginning, and the attendant superficiality, frustration, and discouragement that such conceit invites.

A wise painter has said, "To know Cézanne one does not start where Cézanne left off but where he started."

Discover the craftsmanlike pleasure that comes when you say, "I think that today I have accomplished something I never achieved before." Substitute it for the presumptive attitude, "I am going to do something the world hasn't seen before." You will be not only a happier person but ultimately a greater painter.

Your growth will be the product of an active, searching eye and a busy hand; and, of the two, the eye is paramount. Keep it busy, evaluating, appraising, looking at others' paintings as well as your own even when the hand rests.

Today there are 200,000 serious artists and art students in the United States. Learn to meet their gallant competition by adopting a working schedule and staying with it.

The roadside criticism —

When I first began painting, I set my goal at seven watercolors a week. It seemed a modest number but it was amazing how the basic demands of living competed for each hour.

As a beginning painter, your first thousand watercolors should stick pretty closely to representation. A few experiments to loosen up. A few forays in abstract design. A lot of attention to the translation of the round world to flat paper.

Vary your program by trying other media such as oil painting and print-making. Use little or no color. Stay with line and wash until it talks for you.

As you near the conclusion of this period — which could span years — you will find yourself confident and ready to say something. Then, pull out the stops! Try varied techniques and combinations. Subject matter can become more complex. For instance, instead of the static shapes of still lifes and barns, investigate movement and explore color.

After a few thousand watercolors you will find that you have fallen in love with paper and paint. In the mirror of the paper you will discover your identity as an artist.

Few of us mortals reach this lofty position. I know I haven't. But happily we receive promises and intimations at every step. For the goal is measured by improvement and recorded daily in our growing portfolio of watercolor paintings. As one views the masterpieces of that great English watercolorist Turner, it is exemplary to remember that he is reputed to have produced 19,400 watercolors to make them possible.

LEARNING ABOUT WATERCOLOR FROM OTHERS

A great thorough-going man does not confine himself to one school, but combines many schools, as well as reads and listens to the arguments of many predecessors, thereby slowly forming a style of his own. . . .
— *Kuo Hsi, artist-priest, eleventh-century China*

Doubtless your interest in watercolor painting has been inspired, at least in part, by others' works, and it is likely that your first efforts have been to emulate such prototypes. I hope so, because, as one who has taught many beginning painters, I have found that the ability to borrow creatively from others accelerates individual growth. Don't worry about losing your individuality. Experience tells me that you will find it in the process.

Inspiration and education are everywhere today. Typical are the frequent exhibitions of contemporary watercolor. They should be a subject of studious investigation. By this I mean not just standing back in admiration, but leaning forward to examine and speculate on the step-by-step genesis of any challenging work.

You will be disappointed at the scarcity of historical examples of watercolor, however. This is because museums usually classify watercolor with graphics, and keep the works in portfolios rather than under glass. Special permission is often required to see the originals, but the reward is a chance to view the works intimately. But, happily, no other medium is better represented in prints, books, and magazines.

Sooner or later you will want to know something of the ways of the medium as practiced in the Orient since 300 B.C. and in Europe since A.D. 1400. The following chronology may guide this interest. It should by no means limit it.

LAKE WINDERMERE, Francis Towne. (English, c. 1740-1816)
Collection The Henry E. Huntington Library and Art Gallery

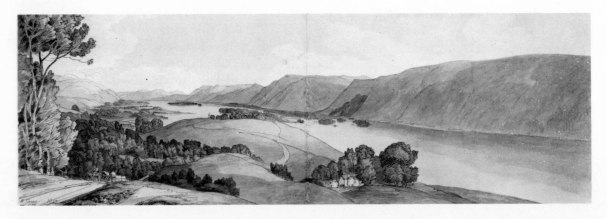

THE EAST: CHINA AND JAPAN

Because the Oriental artist both writes and paints with watercolor, the student should become acquainted with the pictorial arts of China and Japan. He will see how the graduated wash was first introduced in the *Tang* Dynasty (A.D. 618-907); and how landscape painting developed in the great *Sung* epoch (A.D. 960-1127).

The Feudal art of ninth to nineteenth century Japan produced heroic scroll paintings of man, architecture, and nature, such as the widely reproduced "Burning of the Gate" in the Boston Museum collection, while the idealistic Japanese *Ming*, a fifteenth century revival of Chinese *Sung*, produced such landscape painters as Sesshu and Shubun.

In more recent times, the Japanese woodblock prints of Hiroshige, Hokusai, and others have influenced American watercolorists through their disciplined design.

THE WEST: EUROPE AND AMERICA

In Europe, Albrecht Dürer's sixteenth century watercolor landscapes earned him the title "father of watercolor." He was followed by the monochromatic landscape painters Claude Lorrain, Anthony van Dyck, and Nicolas Poussin in the seventeenth century — all well worth knowing.

It was in the nineteenth century that the excitement about light and color raised watercolor to a major medium. Turner, Bonington, and Constable, in England, Delacroix, Monet, and ultimately Cézanne, in France, became its masters.

With the twentieth century came the Expressionists, notably the Germans of the Brucke and Blue Rider Schools. Their need to find a bold, color-filled and personal medium with which to convey often violent feelings led to the development of the explosive wet-into-wet technique.

SECTION FROM LANDSCAPE SCROLL, Mi Yu-Jên. A.D. 1085-1165, China
Courtesy of the Smithsonian Institution, Freer Gallery of Art, Washington, D.C.

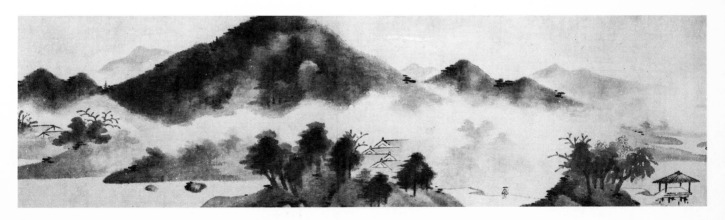

15

American watercolor has parallelled the European Schools for the most part. John Singer Sargent and Maurice Prendergast contributed to the Impressionists' involvements with light and color; John Marin and Lionel Feininger added a structured approach to Expressionist watercolor; and Edward Hopper and Winslow Homer utilized traditional wash techniques to define the American scene.

Today, American watercolor represents many divergent viewpoints which, I believe, is a healthy condition. Some trends:

There is a strong school of **representational** painters that harks back to the days of Winslow Homer. Drawing, design, and complex studio paintings characterize their art.

Synthesists, combining traditions of Occident and Orient, are led by names such as Dong Kingman, Morris Graves, Mark Tobey, and Chen Chi. Value rather than color, calligraphic line and poetic simplifications are typical of these artists.

Experimentation and exhibitionism beguiles another group, many on the West Coast, with a resultant mixture of media and purposes. Not always transparent watercolor, such works are nonetheless stimulating to the serious student.

Largest in number, if not the most influential, are the burgeoning **avocational watercolorists.** Like the gentleman painters of nineteenth century England, theirs is not so much the need to serve society with their artistic achievements but, rather, to find personal satisfaction and a heightened awareness of nature.

Their strength is in their numbers and their enthusiasms; their weakness is a tendency to admire the facile and clever. In spite of such shortcomings, participation in the criticisms, paint-outs, and lectures sponsored by such watercolor clubs can be very rewarding to the beginning painter.

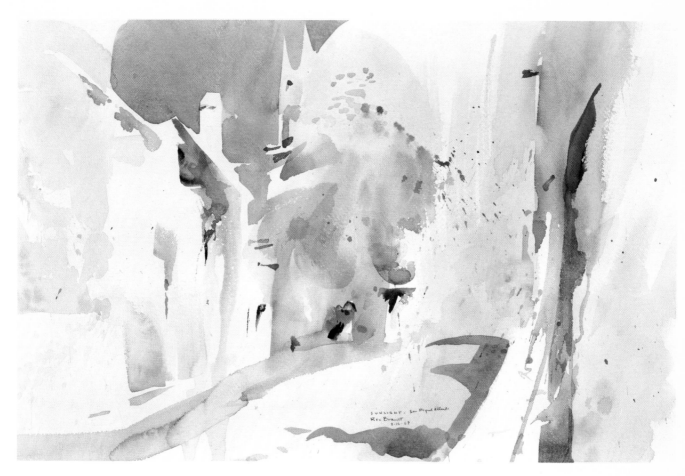

SUNLIGHT, SAN MIGUEL ALLENDE, 13½″x20″ Collection E. Gene Crain

"The way thin color on white paper reflects light is com-
parable to the luster of a sea shell, the translucence of a
tide pool, the luminosity of colored glass against the
sun."

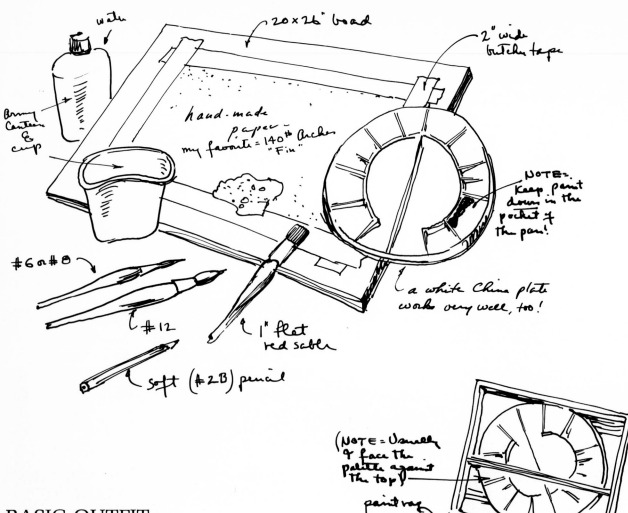

BASIC OUTFIT

There is a substitute for virtually everything shown here, as you will discover in reading the next several pages. However, if you are in doubt, start with this well-tested minimum.

20 x 26 drawing board
140 lb. Arches, rough (half sheet)
2-inch-wide gummed tape
Army canteen and cup
Small natural sponge
"8" or "2B" drawing pencil
No. 8 red sable round
No. 12 red sable round
¾-inch flat sable, short bristle
Plastic palette

Tube colors set on palette: (reading clockwise from the left) Ultramarine Blue, Cobalt Blue, Prussian Blue, Viridian Green, Cadmium Yellow Pale, Cadmium Yellow Medium, Yellow Ochre, Burnt Sienna, Cadmium Red Light (or Vermilion), Alizarin Crimson, Burnt Umber, Ivory Black.

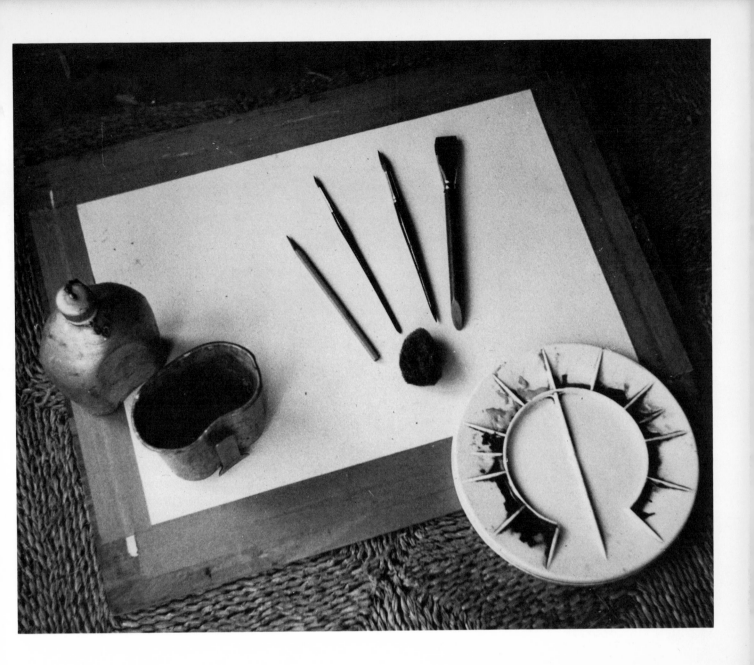

MATERIALS and EQUIPMENT

In selecting materials and equipment it is well to remember the axiom "in art it is not so much what you have, as what you do with it."

Too often I have watched an overburdened student "murder" the paper with a vast array of pigments, brushes, and other gear, while another breaks off a dry twig, dips it in a single bottle of Sumi ink and creates a jewel. It seems that confusion is too often the result of complexity.

Actually, paper and paint are the only critical materials of watercolor. They vary radically in workability and permanence so I devote most of my concerns to them. Selection of other equipment, such as boards, easels, and palettes, is a more personal and non-critical matter — with the exception of brushes. These can vary greatly in size, type, and quality.

PAPER

When two watercolorists get together the talk inevitably swings to paper. Not too surprisingly when one realizes that paper is not only the tangible part of the painting, but that it affects the appearance of both brush strokes and of pigments. A good surface is indispensible to a successful painting. When selecting paper, there are a number of factors to be considered. Review them before choosing a paper; then buy a dozen sheets and give the chosen surface a thorough test.

(1) Absorption

Japanese "rice" paper, like blotting paper or Kleenex, has no sizing or filler. The paint is absorbed with the water. This is fine for brush line, but washes appear lusterless and flat. For this reason most American painters prefer sized rag-base paper.

Such papers have different absorptive characteristics depending on the amount and the location of sizing. For example, Strathmore student paper has the size coat on the surface. Like a well-ironed shirt collar, the result is a rather hard surface in contrast to Arches paper with its sizing deeper into the sheet.

(2) Texture

Watercolor paper surfaces are described by the terms *Rough*, *Cold Press*, *Hot Press*, which derive from the way paper is finished.

Rough accepts a wash well, as each hollow will hold a miniature pool of color — but this roughness does not make for eloquent brush line.

Cold Press is the same paper, ironed smoother by cold steel rollers. It responds to brush line more readily, and yet it is dimpled enough to accommodate a wash.

When heated rollers are used to smooth the paper all dimpling disappears and we have a smooth **Hot Press** surface ideal for pen-and-ink or brush line. But such paper is not as popular with watercolorists because it is difficult to run a wash on so hard a surface.

(3) Weight

Weight — the thickness of a sheet as expressed in pounds per ream (500 sheets) or in plys, the number of laminations — influences the way paper responds to watercolor. For example, compare the one-ply (70 lb.) Arches Torchon (Rough) with the two-ply (140 lb.) sheet of the same make and surface. You will discover that the lighter sheet seems to have less texture and so handles calligraphy better; the heavier sheet accepts water more deeply and is the better for wet-into-wet painting.

OTHER CONSIDERATIONS

(4) Permanence

Today may be the day for that "HAPPY ACCI-DENT" — You may wish to preserve your painting forever!

If the sheet is one of the cheaper wood pulp papers, chances are that within a short time it will turn yellow, become brittle, and even disintegrate. To avoid this I suggest that all work be on one of these non-yellowing surfaces:

(a) All-linen rag paper.

(b) "Rice" paper, actually made from fibers similar to linen, not rice.

(c) Synthetic fiber (plastic) paper.

Each of the above types receives water in a different way and therefore produces different results. For example, Dale Meyers, A.W.S., finds that she can push paint about on synthetic paper with a drinking straw used like a blow-pipe because of the relative impermeability of the plastic surface.

(5) Dimension

Most hand-made papers are formed approximately 22″ x 30″, the *full sheet*. A favorite size for exhibitions, it is too large for most beginners and difficult for outdoor work. Divided in half, the *half sheet*, approximately 15″ x 22″, is a more popular and manageable size. *Quarter sheets* (half of a half-sheet) sell well and also are good for quick studies.

At the other extreme, *double elephant*, 25″ x 40″, is about as large as most experts will go, although machine-made roll papers are available to almost limitless dimensions.

If you buy a machine-made paper — characterized by having a grain, or tendency to tear more easily in one direction than the other — care should be taken to see that the manufacturer specifies "all-rag content."

(6) Control of buckling

Although accidents are endemic to watercolor, I see no reason to be victimized by unintentional puddling, the result of the buckling or cockling of the sheet when wet. Here are some ways to avoid it:

(a) Buy a pre-mounted sheet, (illustration board). Problems: High cost; tends to warp, if not to buckle; and the paper surface works differently because of the effect of the glue used in mounting it.

(b) Use a heavy watercolor paper. Problems: Higher cost; and it is difficult to control the depth of moisture.

(c) Paint drybrush style and avoid excessive moistening. Problem: Limits the variety of techniques that can be employed.

(d) Work the buckle out while painting, by moving thumbtacks or paper clamps every few minutes. Problems: Only partially effective; and it interrupts the painting process — unless, like George Post, you have done it so many thousand times that it is automatic.

(e) Soak the sheet and paint while it remains wet. Problem: Limits the time available and the techniques.

(f) Stretch the paper by soaking the sheet, causing it to expand. Then, fasten it down and let it dry so tensioned. Now, when you wet it, it will *not* buckle.

Happily this tensioning or stretching can be done in your spare time. Although you may experience a failure or two, evidenced by the tape loosening or even splitting, you will soon master the skill of paper stretching if you observe the following cautions.

HOW TO STRETCH PAPER

The secret is to have all your gear in order and to work fast. Use 2-inch-wide heavy butcher tape. If a narrower tape or lighter weight is used, double or triple the thicknesses, overlapping each a little. Do not use masking tape; it will not hold to the wet sheet.

(1) Clear the space. Work on a smooth table near a sink or bathtub, or on a smooth drainboard. Be sure that everything is clean: no paint, glue, or grease around. (Don't work in the kitchen where frying has been going on or the paper will pick up particles of grease from the air and so be difficult to work on later.) Try to allow enough space for laying out your strips of paper tape when you moisten them. See that the surfaces are dry before you begin operations.

(2) Assemble all of your materials before you get your hands wet.

(3) Trim the paper to size.

(4) Cut the tape. You will need four pieces, about 2 inches shorter than the paper's dimensions.

(5) Hold the sheet to the light to see the watermark; this indicates the preferred side or face of the paper — the side from which you can read the name of the manufacturer, etc. Then turn the paper over and lay it face down flat on the board or table.

(6) Wet the entire surface, using a clean rag or sponge and (preferably lukewarm) water; stroke it first in one direction, then in the other to be sure it is moistened completely.

(7) Turn the paper over carfully, place it on the board square to the corners and wet the face (now up) in the same way. It may be necessary to blot up some of the water with clean rags or newspaper before the next step.

An alternate method: Submerge the whole sheet in a sink or bathtub full of water; hold it up by one corner to drain, shake out the excess moisture and place it on the board.

(8) *Now work fast! If you delay, the wet paper will be hard to handle.* Lay one of the long gummed strips flat on the table or sinkboard, glue side up, and drag a moist sponge or rag the full length. This is important and the point at which many stretch jobs fail: Be sure that the glue is completely moistened, otherwise it won't stick to the dry board. But do not scrub it or you will take off so much of the glue that the tape will not stick to either the paper or the board.

(9) Turn the strip over and lay it straight along one of the long edges of the sheet, being sure that there is at least ¾-inch of tape on both the paper and the wooden margin. Press it down the whole length. Do not try to smooth out wrinkles from the center of the sheet.

(10) Now moisten the other strips and press each down firmly.

(11) Rub all the tape strips with a fingernail, following the edge of the paper underneath. Repeat this in a few minutes, if necessary, to eliminate air bubbles and to make the glue stick.

(12) Keep the board flat until the paper is completely dry. This means not standing it up on edge, for the water will seep downward and loosen tape that seems to be adhered. (Don't be disturbed by the buckling in the paper; all that will smooth out with time.)

Drying time depends on the weather. On a moist winter day it may take several hours or overnight. It can be accelerated by laying the board flat in the sunshine; or by covering the entire surface with a large dry blotter, or sheets of paper towelling and then a second board and applying pressure.

ALTERNATIVES TO GUMMED TAPE

(a) The sheet may be glued to the board at the edges. A fast setting vegetable-type paste is necessary or you lose the stretch.

(b) Metal staples, ¼ inch deep, may be gunned to the margins at two-inch intervals. Easy to apply but hard to remove.

(c) The sheet may be drummed over a stretcher-bar frame and held in place with staples or thumb-tacks on the back at regular intervals.

(d) A number of commercial stretcher frames are available but they do not seem to be widely popular.

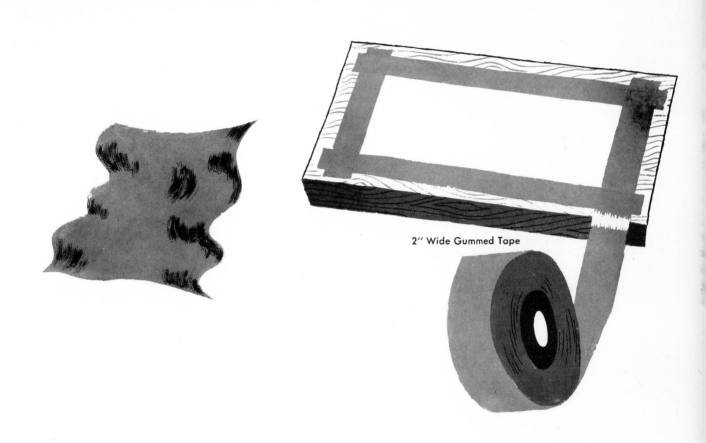

2″ Wide Gummed Tape

PAINT

Theoretically the painter needs only three colors — the primaries: Red, Yellow, and Blue. With a saturate panful of each he should be able to mix the secondary hues of green, purple, and orange and, by intermixtures, to create grays and blacks.

In practice this is not feasible because good pigments do not correspond to the perfect physical divisions of the color spectrum. (Refer to Lessons 1 and 2.) For this reason, compromises and adjustments are a necessity in selecting an assortment of paints. Here are some of the considerations in choosing a palette:

(1) Permanence
Pigments derive from minerals, organic materials, and chemical products. Most earth colors are gray, non-fading, heavy-bodied, and permanent, while organic colors such as the vegetable dyes will fade with time and have no body. They are intense and stain-like but seldom employed, except in art for color reproduction where permanence is not a consideration.

Manufacturers have developed synthetic substitutes for both mineral and organic pigments. Some are permanent, others fugitive. Some have body, others do not. Happily they include enough permanent (non-fading) pigments to replace the fugitive colors that have contributed to the failure of a few masterpieces of the past. One example is *New Gamboge,* a synthetic substitute for the fugitive organic pigment Gamboge.

(2) Body
Some pigments have a jewel-like body that both reflects and refracts light but veils the paper, thus appearing more opaque: Ultramarine Blue is an example. Others are bodiless dyes that stain the paper with a brilliant translucence: Prussian Blue is an example.

(3) Workability
Some pigments mix well, stay moist on the palette, and dry evenly (Ultramarine Blue is an example). Other pigments (Viridian Green, for example) do not. Some mix almost too well (Prussian Blue and Prussian Green, for example) seizing and coloring other pigments aggressively.

Because of these differences the artist will wish to add extra, workable colors, and restrict his selection of the less-workable ones to those colors that cannot be duplicated otherwise. He may augment the basic palette with earth pigments. These can be employed as basic mixes or stocks to be modified by the addition of small bits of intense pigment.

SELECTING A PALETTE
(Refer to "Color Wheel," page 38)

Because there are no good purples and few greens, we mix these by using a pigment nearest to the target color. To make a good green, use a "greenish" blue such as Prussian Blue and a "greenish" yellow such as Cadmium Yellow Pale. Similarly, to make a clear purple, mix a "purplish" blue — Ultramarine Blue — with a "purplish" red, an Alizarin Crimson, or a Thalo Red. To achieve middle blue, mix the two blues. And so on around the spectrum. In this way about six colors, two of each primary, will reproduce all visible color. Here is a typical palette:

Yellows:	*Cadmium Yellow Pale or Lemon* *Cadmium Yellow Medium*
Reds:	*Chinese Vermilion** *Alizarin Crimson*
Blues:	*Ultramarine Blue* *Prussian Blue**

To improve the range of greens, add Viridian Green or Prussian Green. To provide a honeylike, semi-opaque blue for skies, haze, and aerial perspective, add Cobalt Blue. To darken (shade) the above colors without destroying their chromatic purity, add Ivory Black. And finally, to speed up color mixing and to avoid excessively dirty grays, add the earth colors — Burnt Sienna and Yellow Ochre.

The above list is extensive enough to cover the spectrum and in addition permit both thin, stain-like washes and matching heavier-bodied glazes.

*See page 25 for alternatives

Some teachers do not recommend black; however, without it the artist cannot shade color. Also, there is some polarity of feeling about that historically popular pigment Yellow Ochre. Some condemn it for its opacity but this can be said of any yellow, for the color *is* aggressive and must be used sparingly. The only transparent, permanent yellow is New Gamboge. If you favor intense, stain-like color or are painting for color reproduction, you might substitute it for Cadmium Yellow Medium or Yellow Ochre.

BUYING PIGMENTS

Watercolor pigments are sold in pans or tubes. Because the pan paints require less glycerine for moistening they seem a bit more brilliant than tube pigments. But time consumed in working them up with water, and the wear on expensive brushes to achieve this, makes them less popular than freshly set tube paints.

With a palette comprised of permanent pigments the distinction between cheaper "student" and more expensive "professional" pigment is now more a matter of the grind than of the color, for it is possible to grind a pigment too fine — thus powdering it to a chalky tint — or to grind it so coarsely that the result is dark and lacking in a sense of luminosity. Ultramarine Blue is a typical example.

The painter can buy quadruple (¾″ x 3″) tubes of finest artists' color for approximately the same price as three single (½″ x 2″) tubes of student color. Because of the better grind, his work will be enhanced at no additional cost — provided he plans to use up all the pigment within a year or two.

The following list names some of the most-used pigments. Remember that you do not need all of them. Read Lessons 1 and 2 before you buy any, since each manufacturer has his own variations and brand names.

PIGMENT CHARACTERISTICS

YELLOW

Cadmium Yellow Medium: Permanent warmish yellow. Rather opaque, so avoid overloading the wash with it.

Cadmium Yellow Pale or Lemon Yellow: Same as above but cooler (greener) and ground finer. The cadmiums need to be mixed with a good amount of glycerine for ease of working as they are rather stiff otherwise. Look for a soft tube.

Gamboge: A warm yellow, and the only stain yellow. It is very useful but classified as impermanent. Most colormen list a permanent alternative under such trade names as **New Gamboge** or **Gamboge Hue.**

Naples Yellow: A permanent warm pale yellow, very opaque.

RED

Alizarin Crimson: A cool, intense stain red. Most saturate of all colors, so a little goes a long way. Used with much water to make a thin pink, it does well as underpainting for green hills and trees. Because Alizarin will fade somewhat, many painters have replaced it with **Thalo Crimson** or **Monastral Red** — an intense, permanent stain.

Vermilion: A warm red, permanent when made from cinnabar **(Chinese Vermilion),** but impermanent if the English variety. It is opaque and glowing in quality.

Cadmium Red Light: A permanent warm red and a good substitute for Vermilion, although lacking its ultimate glowing warmth. It mixes well with the Cadmium Yellows to give a range of orange colors.

BLUE

Ultramarine Blue: A permanent warm blue with excellent working qualities. It may dry with a chalky appearance in the cheaper brands, which are ground too fine, so buy a tube of the best.

Phthalocyanine Blue (trade names, **Monastral, Prussian Blue,** or **Thalo Blue**): A cold, intense, stain blue. It seizes the yellow pigments, staining them a variety of rich greens. It even stains Burnt Sienna to a deep bottle green. Use with caution and plenty of water.

Cobalt Blue: A permanent light middle blue, opaque but honey-like and workable. Excellent in glazes or in wet-into-wet where its body holds it in place, resisting the tendency to "bleed."

Cerulean Blue: Greener than Cobalt Blue, it has much the same uses although a greater tendency to precipitate.

Manganese Blue: A green blue. It is difficult to apply smoothly as it precipitates rapidly. It dries with a jewel-like granulation.

SECONDARY HUES

Thalo, Prussian, or **Monastral Green:** Intense, permanent stain. Mixes well, but it is most aggressive. Use it with restraint.

Hooker's Greens: Several warm, workable greens. These are listed on a good many palettes. Originally fugitive, the new synthetic equivalents are rated permanent.

Viridian Green: A permanent blue green, it is the best of some bad choices in greens. It is slippery, mixes poorly with water, dries hard and cakes in the pan. However, it does give a transparent and permanent green.

GRAYS AND NEUTRALS

Payne's Gray: A cool black of very fine grind, smooth and moist. I use it to shade other colors, deepening them with no loss of clarity. It may substitute for blue on a limited palette.

Lamp Black: A smooth permanent black.

Ivory Black: A permanent warm black, it granulates unpredictably.

Earth Green (Terra Verte): A permanent warm gray-green, semi-opaque.

Yellow Ochre: A permanent earth yellow often used in preference to the more intense cadmiums. It works well but dries fast, sometimes forming islands in the wash.

Raw Sienna: Similar to Yellow Ochre but more transparent. It works well but hardens in the pan and has to be set out fresh each day.

Raw Umber: Like Raw Sienna but darker and with more body.

Indian Red: A permanent, cool earth-like red with excellent working properties. Except for the fact that it dries rather hard in the pan, I think this color is too often overlooked.

Burnt Umber: A permanent earth brown on the cool side. Because it does not mix well with glycerine it is often unworkable as it comes from the tube.

Burnt Sienna: A permanent warm gray-orange with excellent working qualities. Buy a large tube.

China Plate

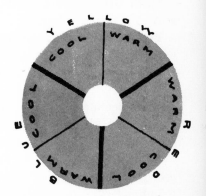

PALETTES

Large, heavy palettes are generally best for studio work, and the lighter, smaller palettes for work in the field. The surface must be white. Pans should be deep and located in such a way as to wash off easily. Plastic palettes usually have fewer sharp edges — which cut bristles — than metal ones. A circular palette is more awkward to carry, but useful for color planning when the pigments are set in the sequence as they occur on the color wheel. There should be at least two pans for big washes — one for cool mixes and one for warm colors.

Setting the Palette

(a) Sequence of pigments should be logical. Although every painter has his own way, depending on his colors and the shape of the palette, most keep the lighter colors separated from the darker ones. For example, place yellow at the opposite end from purple or black. Some artists set earth colors apart from intense colors. I prefer to place them in their proper spectrum position.

(b) Squeeze tube from the bottom and roll up as it is emptied, to avoid dry pockets in tube.

(c) Squeeze a generous portion (approximately half a teaspoonful) into the corner pocket of the pans provided on palette. Don't put pigment out on edges of palette, where it cannot be moistened easily.

(d) Always cap tube firmly. If the cap is stuck, heat with a match and then, protecting fingers from hot metal with paint rag, unscrew the cap.

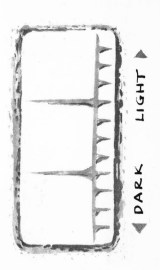

BRUSHES

Minimum requirements are one brush to cover large areas and one brush for line. When new, one brush will do — a good quality No. 10 or No. 12 red sable round, if it will point well enough to handle detail and line and at the same time carry sufficient paint to make a wash. The point will wear with use, and then it becomes necessary to add a smaller, pointed brush. Recommended: A good quality No. 6 or No. 8 red sable round.

A long, resilient sable bristle, well-cupped, choked deeply in the ferrule, is the ideal that applies to all round brushes. Look for ability to point and for resiliency, rather than length of bristle.

A MONEY-SAVING TIP. Most brushes are rather casually graded. For this reason it is possible to pick up a bargain if you do the following: Choose a store or a line where there are 15 or 20 brushes of the same size, make, and price. Test each one by dipping it in water and shaking it out. If it is a good brush the bristles will form a symmetrical point — a poor one may split or splay. Of 15 brushes, for example, five will be so poor as to be no better than a cheaper line, five will be average, but five will compare with the next more expensive line — so choose one of these.

A flat brush is good for washes, too, and in addition gives an architectural or cubistic effect to the painting in contrast to the "ropey" quality of the round brush. Recommended: A ¾" or 1" red sable flat. If you find the cost of sable bristle prohibitive, try an oil painter's ox-hair bright. Mario Cooper, N.A., has discovered that some brands of these modestly-priced substitutes compare well with red sable. His favorites are the 1½"- and 2"-wide sizes.

For broad washes some watercolorists acquire a 2" or 3" wide, high-quality varnish brush. I prefer a leaner Japanese brush, either the 2"- or 3"-wide Hake. *(Most other Japanese brushes, such as the color brushes, blenders, and stroke brushes, are not resilient enough for Occidental scrubbing, drybrushing, and color mixing habits.)*

Wash your brushes well after use, occasionally with Ivory soap. Protect the points with a suitable carrying tube or case. Above all, don't mix India ink, casein, or plastic paint with your best watercolor brushes as these mediums leave a film that cannot be completely removed.

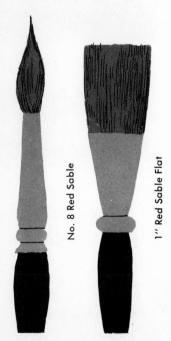

No. 8 Red Sable 1" Red Sable Flat

OTHER EQUIPMENT

THE WATERCOLORIST'S KIT

Shall I buy an easel and a box, or a box-easel? Will I need a stool or may I sit on the ground?

Questions about equipment are as endless and varied as are the answers, depending on some of the following circumstances:

Studio vs. Outdoors

If you are going to work indoors, the problems of support for your board are quickly and inexpensively solved by utilizing a table top. And equipment storage is limited only by available space.

But when you paint outdoors — and certainly watercolor invites you to do this — the problems of portability, support, and storage arise. Indeed they may become so demanding as to make good painting impossible.

A balanced relationship of materials and equipment will greatly facilitate outdoor work. This means selection of a husky easel, adequate palette, and good-sized brushes if you wish to paint a full sheet; conversely, assemble smaller brushes and lighter equipment for the quarter-sheet sketch or note-book study.

Portability

The size of your painting will be influenced by ability, available time, and the subject, but above all, by portability. If you are traveling by car or station wagon you will be able to transport enough gear to paint a full sheet; but the hiker, the air traveler, or taxi rider is restricted, thus less equipment and smaller paper sizes are indicated.

Standing vs. Sitting

A teacher once said, "No great work was ever painted sitting down." Although personally I prefer to stand, I cannot agree with him completely. There are handlings that invite a contemplative, seated approach — just as there are subjects that demand a standing attack. I feel easier painting a seated model if I am seated, but I am frustrated if I cannot stand to paint a standing model.

Your subject may dictate whether you stand — or sit: For example, the hedgerows of Cornwall, like the redwood fences of Mendocino, make standing a necessity if one is to see over them. On the other hand, the crowds and activity of a Nassau waterfront have forced me to sit out of the way on the edge of a beached boat.

If you sit, the board may be propped by a box, a brick, or even a purse, but you will be limited as to the size of your painting. If you stand, provision must be made for having water, palette, and brushes within reach.

Cost and Convenience

Too many beginners overburden themselves with equipment in a desperate effort to emulate the conditioned professional. Some arrive in our foreign workshops with so much extra luggage and equipment as to cause frustration before they even begin to paint.

I urge *"Keep it simple."* Fit half sheets and two boards into the bottom of the suitcase; assemble everything else in some sort of modest outfit such as those illustrated on these pages. Learn to do well with a little, rather than letting a lot do *you.*

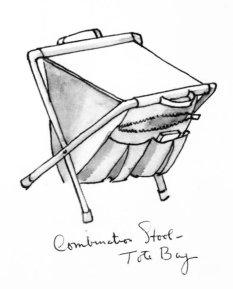

Combination Stool-Tote Bag

BOARDS

Thumbtack, clip, or stretch your paper to a board while painting. A standard 20″ x 26″ pine or basswood laminate, not less than ¼″ thick, is recommended. One thin coat of shellac will waterproof it. Don't use varnish if you expect to hold down your sketches with gummed tape, for it will not adhere.

Larger boards for studio work may be standard drafting boards.

WATER

As much clean water as possible is required. Remember that paint mixes more quickly in mildly warm water than in cold. The container should be unbreakable and have a wide mouth. The one-quart Army canteen-and-cup combination (illustrated) is a minimum. Many watercolorists keep two containers on hand, using one for brush rinsing and the other for color mixing.

Add a drop of detergent, which includes a wetting agent, to reduce "pin-holding" of washes. Other additives are listed on page 86. They are not necessities.

SPONGE

A small, natural "cosmetic" or "silk" sponge is useful for wetting paper, cleaning the palette, lifting color, and even as a paint applicator. Avoid the popular cellophane sponges — they are not comparable.

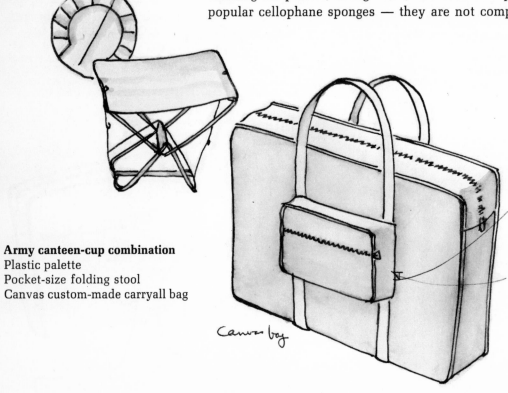

Army canteen-cup combination
Plastic palette
Pocket-size folding stool
Canvas custom-made carryall bag

Canvas bag

OPTIONAL ITEMS

A medium-soft pencil (HB, F, or No. 2) is useful for sketching and composing, as is a soft rubber eraser for removing unwanted lines.

PAINT BOX

Storage (the painter's box or kit) is a personal matter. George Post, for example, uses a leather overnight case for all his equipment except his board. Some painters employ a handbag, a briefcase, or a map case. The paint box may be of wood, metal, or plastic. A favorite is the fisherman's tackle box with inner tray compartments.

EASELS

Except for a quick sketch or a novelty handling of some sort, no artist holds his board in his hand or his lap; some provision must be made for its independent support. Because the board must be maintained in a more horizontal position for watercolor than for other media, the selection of an easel or other device is quite specialized. This fact may explain why watercolorists as a lot are so inventive in devising equipment. Some typical solutions to the problem are illustrated on the following pages.

Sketch Kit for the air traveler
Everything fits into a leatherette case: 8½″ x 11″ sketchbook; brushes rolled in newspaper; plastic palette protected by newspaper; an ice bag for water, and a folding stool. Total weight: About 5 lbs.

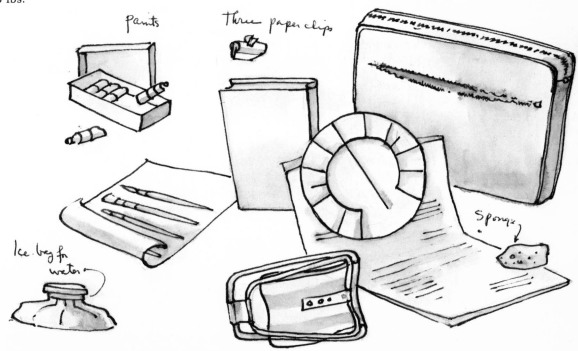

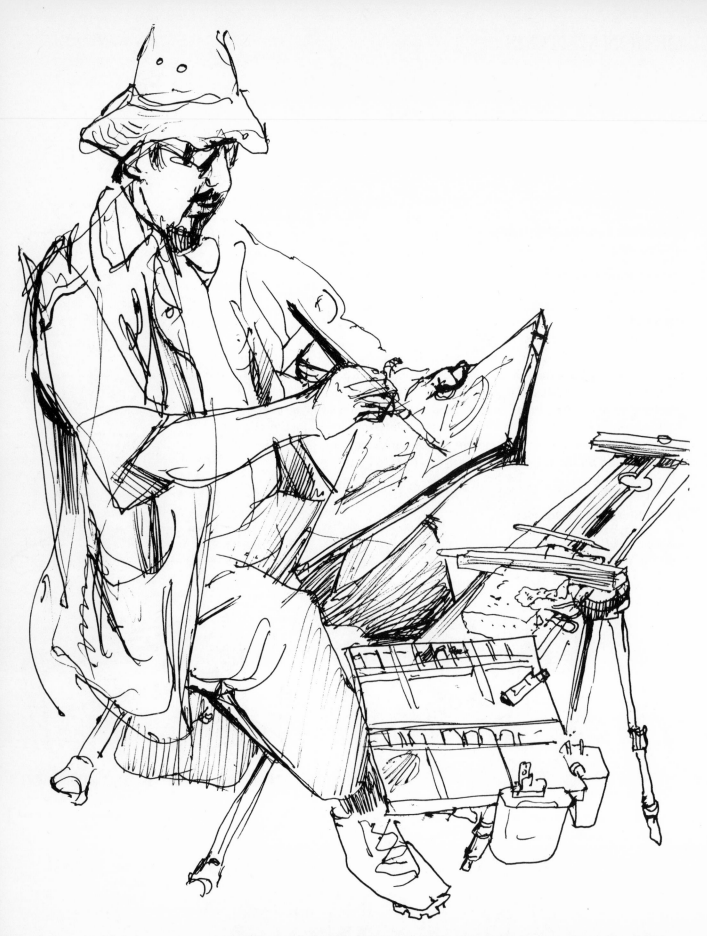

Mario Cooper, N.A., sketching on location. His preliminary studies are prepared on a small sketch block before placing his board and paper on the easel. Note the *two* plastic water containers clipped to his metal palette. The combination stool-tote bag on which he is seated is illustrated on page 29.

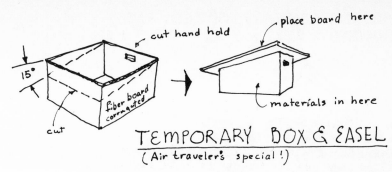

cut hand hold

place board here

15°

fiber board corrugated

cut

materials in here

TEMPORARY BOX & EASEL
(Air traveler's special!)

WATERCOLOR

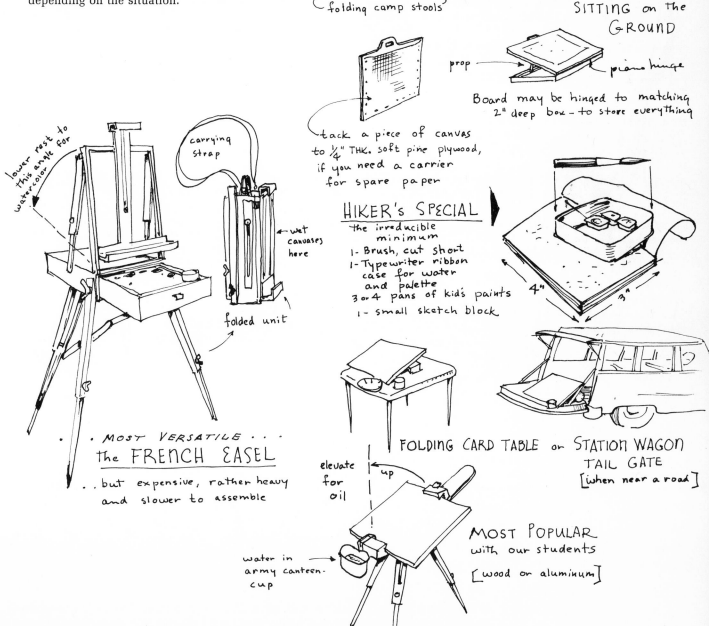

Equipment For Working Outdoors
Suggesting a wide latitude of choice, these devices vary in price from a free cardboard box to an expensive French easel; and in size from a hip pocket "Hiker's Kit" to a folding card table. There is a place for each, depending on the situation.

prop with box, brick, or purse

folding camp stools

15°

Stick or stone

FOR KNEELING or SITTING on the GROUND

prop

piano hinge

Board may be hinged to matching 2" deep box - to store everything

tack a piece of canvas to ¼" THK. soft pine plywood, if you need a carrier for spare paper

HIKER's SPECIAL
the irreducible minimum
1- Brush, cut short
1- Typewriter ribbon case for water and palette
3 or 4 pans of kid's paints
1- small sketch block

4" 3"

lower rest to this angle for watercolor

carrying strap

wet canvases here

folded unit

. . MOST VERSATILE . . .
the FRENCH EASEL
. . but expensive, rather heavy and slower to assemble

FOLDING CARD TABLE or STATION WAGON TAIL GATE
[when near a road]

elevate for oil

up

water in army canteen-cup

MOST POPULAR
with our students
[wood or aluminum]

33

QUESTIONS ABOUT MATERIALS AND EQUIPMENT

Do any painters use less than six colors?

Yes. For example, here is "The Holy Trinity," favorite of the early English watercolorists: Cobalt Blue, Yellow Ochre, and Light Red. My favorite low-keyed limited selection: *"The Velásquez Palette,"* shown on page 121. A high-keyed one: Ultramarine Blue, Cadmium Yellow Pale, and Alizarin Crimson.

You might add a good two-color palette: Prussian Blue and Burnt Sienna.

Do you recommend buying the large (quadruple) size tubes?

Yes. If you plan to do much painting they are an economy, as you get nearly five times as much paint. Ultramarine Blue and Burnt Sienna, the most used colors (they mix to make such a wonderful series of grays) should be purchased in large size. Intense colors such as Alizarin Crimson, Prussian Blue, and Vermilion, where a little goes a long way, may be purchased in smaller sizes.

How do you loosen the cap on a tube of paint?

Roll the used part of tube up tightly so that paint fills all the remaining tube. Then twist it. If it is still stuck, try pliers. If this doesn't loosen it, heat the top with a match to expand the cap. If none of these succeed, unroll the tube and squeeze the paint out of the other end.

I have some old tubes of paint that have hardened. How can I make use of them?

Save them to throw at your next critic. That's all they are good for.

For a doubtful tube: Loosen the cap and put the tube upside down in a glass of water. Leave it overnight. Sometimes moisture will be drawn into the tube, remoistening the paint.

May I use pan paints?

Yes. Actually they are less full of glycerine and other additives, but they are slower to work with and wear out many a brush.

Do you believe in using black as a pigment?

Yes. Both as a "color" and as a device for shading color. I do not like it in little pieces (limbs of trees, windows, etc.). For such purposes use a deep rich color instead.

With so much emphasis on limited palettes and tonal palettes, why all the extra colors?

The full palette is like a piano keyboard. All the keys are useful, but seldom are all used in any one composition.

What pigments are used for painting flesh?

Burnt Sienna, Alizarin Crimson Golden, Rose Madder and Yellow Ochre are particularly useful. Cobalt Blue mixed with Alizarin Crimson makes a beautiful violet glaze for shade and shadow.

I'm confused as to terms. What are watercolor, gouache, tempera, and so forth?

Transparent watercolor: Pigment, gum, moistening agent such as glycerine, and material to break surface tension such as ox gall. Light reflects from the white surface of the paper.

Gouache: Same as above, with addition of clay filler, which makes all colors opaque.

Poster Paint or Distempera: Similar to gouache.

Tempera: (Sometimes *True Tempera* to distinguish it from *Commercial Tempera* or *Poster Paint*) Broadly, any gelatinous or colloidal medium. In practice, egg is the emulsifying agent. Light may be reflected from the ground (paper or gesso surface) or clays may be added to veil ground and reflect light.

Plastic Paints: Synthetic resins derived from acrylic acid or vinyl acetates, or mixtures thereof (copolymers) mix with water but dry water insoluble — and rapidly.

Casein: A binder derived from milk. Its performance is similar to the plastic mediums.

May I use indelible inks or some of the dye brands of watercolor?

Yes. They are brilliant and pure, and excellent for commercial work. Having no body of their own, they lack the jewel-like glow in the original that is associated with pigment paints. Few are permanent. I advise running a light test in case of doubt. The blacks and brown colors are the safest bets. The quick drying inks are among the worst!

Do I have to set out fresh color each day?

No. Start with plenty of color down in the bottom of the pans. Wash off the palette *before* painting, not after, and you will find that only a few colors need replenishing each day.

What size sheet should I use?

Not too big! The idea that big, free paintings come from big sheets is overrated. I would like to see the students do a hundred half sheets before presuming to execute that "tour de force," a full sheet.

What's wrong with the cheaper student paper?

Machine-made, cheap papers have the sizing all on the surface — a hard top and soft inside. Most are neither as receptive as pure linen rag papers, nor as permanent.

How can I tell a good paper from a poor one?

Trial and error. These tests help: (1) Tear a corner of the sheet. If handmade, it will tear with difficulty in a jagged, resistant break. Machine-made paper tears easily in one direction, with the "grain." (2) Burn a small piece; cheap paper leaves a hard, clay-filled ash. (3) Cover half the sample and expose it to light and air for a few weeks. Remove cover and see if any yellowing has occurred. Yellowing is evidence of wood pulp, therefore of instability.

Do I have to stretch my paper?

Enough accidents happen in watercolor without inviting the unpredictable ups-and-downs of a buckled sheet. However, if you are planning to work in drybrush, or if you can lay a wash with the quick touch of Phil Dike, Edgar Whitney, or George Post you may try the unstretched sheet. Regardless, the sheet should be flushed with clean water before painting; this removes any grime or oil, to ensure a surface receptive to watercolor.

If I use very heavy paper or mounted paper can I avoid the need to make a stretch?

Yes. A 300-lb. sheet will not buckle enough to make trouble. However, Barse Miller, N.A., is one famed watercolorist who contends that even this heavy sheet is better when stretched.

An observation: The heavier sheet works differently; it takes water deeper into it. Conversely, in the mounted sheet, the glue with which it is bonded acts as additional sizing, forming a resistance to moisture.

How can I protect the stretch when it is drying or being carried?

Thumb-tack a few thicknesses of newspaper or blotting paper over the board.

How do you protect the brush tip while carrying?

Staple a piece of elastic or rubber band to your box or board. Tuck the brush into the loop thus formed. Always keep the brush clean and the bristles pointed together.

Why all the emphasis on transparent watercolor? Don't you like opaque?

You bet I like opaque. And oil. And pastel. But transparent watercolor is a unique medium with its own beauty and problems. I stress holding the light of the paper surface, which is the essence of this uniqueness.

Is it true that watercolor is not as permanent as oil?

No. There is little that can go wrong with good paint on 100 per cent rag paper. Fading color is no longer a problem since vegetable dye colors have been eliminated from the palettes. A sheet with excessive sizing may mildew if exposed to the damp, but this is easily avoided or repaired.

Paintings of the seventeenth and eighteenth centuries in the British Museum are described as "fresh as the day they were painted." There are examples executed hundreds of years before oil painting was known.

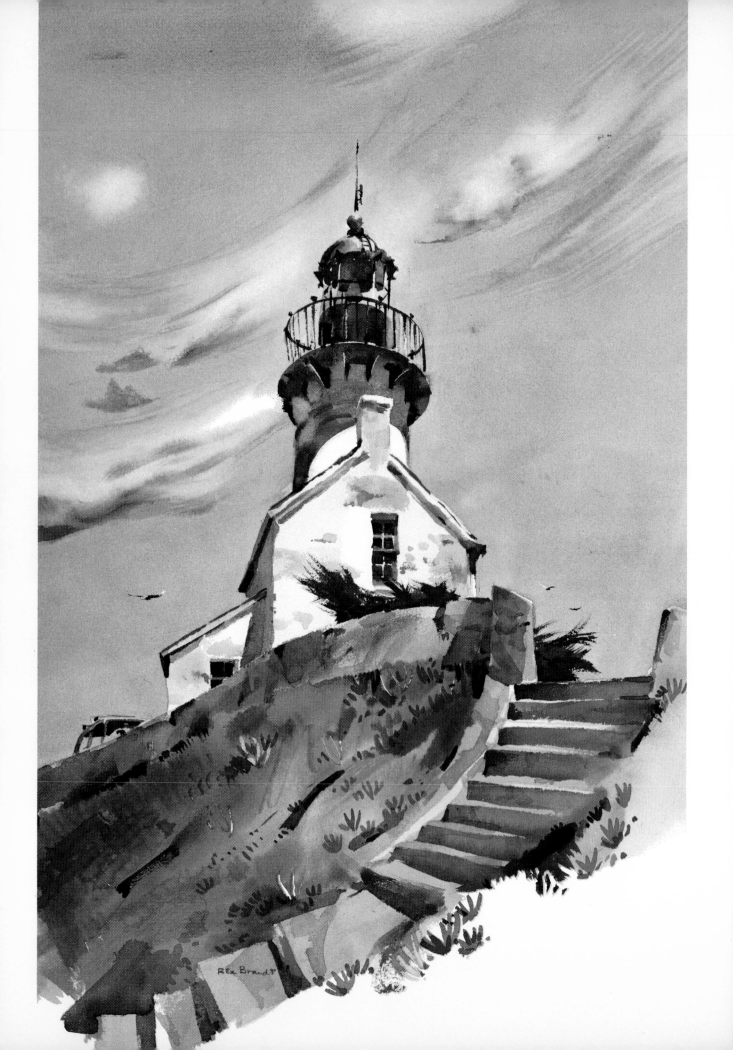

THE LESSONS

The following lessons have been developed and tested over a period of years. Each is an important step and each step is prerequisite to the mastery of the next lesson.

The steps are divided into two parts. The first ten lessons are designed to acquaint the painter with the techniques or tools of watercolor, with little or no emphasis on making a painting. The second ten lessons explore the ways by which the techniques are incorporated to make watercolor paintings. Plan to undertake them in the sequence in which they appear and you will have success!

Before beginning, be sure that you have all the necessary equipment and lots of paper. Do not be surprised if you redo each lesson a dozen or more times. Try not to worry about any one painting, but set your goal on doing three or four trials of each assignment.

At first you will depend too often on that familiar tool — a pencil. Restrict its use to layout lines, learning to use the brush for everything else as ultimately you will find the brush more versatile.

John Marin once said, "Painting is like golf; the fewer strokes I take, the better the picture." Get this feeling of making each step count.

The first ten lessons: TECHNIQUES

An example of the textural variety available to the watercolorist who utilizes the techniques that are the subject of the first ten lessons.

The sky employs the *wet-into-wet* technique to softly feather the edges of cloud shapes.

Shade and shadow are defined by *washes* which have been animated by *wet-blending* or *charging*.

Drybrush is utilized for the rough texture of the wind-blown cypress tree, *brush line* for the patterns of plants in the foreground.

Opposite:

OLD POINT LOMA LIGHTHOUSE, 21″ x 13″ Copley Foundation Collection

PIGMENT POTENTIALS

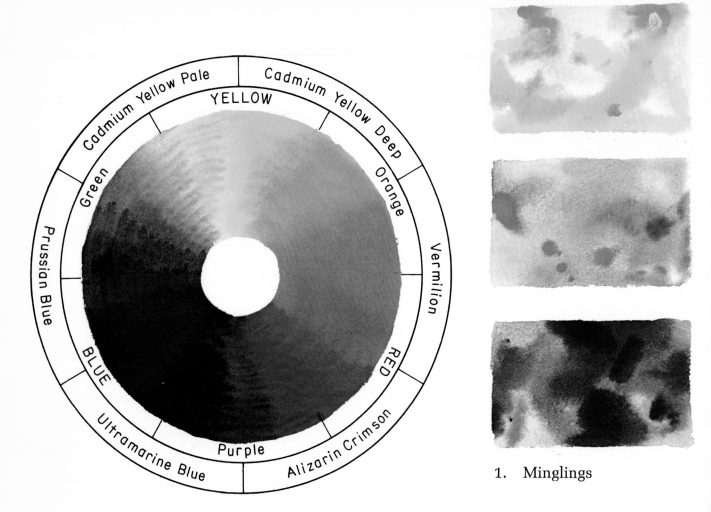

THE COLOR WHEEL

Color wheel labels: YELLOW, Cadmium Yellow Pale, Cadmium Yellow Deep, Green, Orange, Prussian Blue, Vermilion, RED, BLUE, Ultramarine Blue, Purple, Alizarin Crimson

1. Minglings

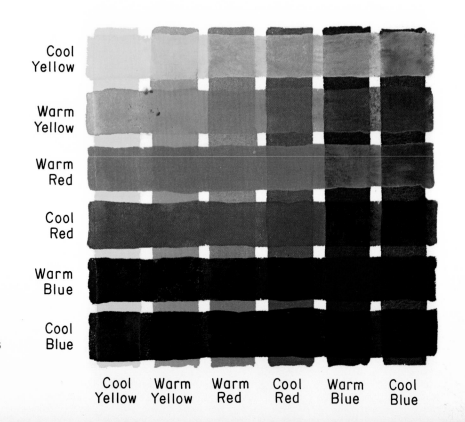

2. Pigment Characteristics

Rows: Cool Yellow, Warm Yellow, Warm Red, Cool Red, Warm Blue, Cool Blue

Columns: Cool Yellow, Warm Yellow, Warm Red, Cool Red, Warm Blue, Cool Blue

EXPLORING PIGMENT and WATER

Remember the colorful wet stone you picked up on the beach and the disappointment when it dried and the color seemed to fade?

It happens with watercolors too. We must learn to anticipate this by "charging" the color — that is, reinforcing or overstating the wet mixture.

Another challenge of transparent watercolor is its exaggeration of pigment differences — some sink in or stain the paper; others float opaquely on top, veiling or glazing the surface.

This lesson explores these propensities. Use just enough water to achieve a good mixture and plenty of pigment.

Assignment:

(1) Minglings

Divide the sheet and mark one-half of it into six squares about 2 x 2 inches. Wet the surface of square no. 1, and mingle into this wet square all the varieties of yellows you have. Have some parts thin (tints), some thick (impasto or *charged*). Do the same in square no. 2 with reds, and square no. 3 with blues.

In the next three squares, make similar minglings of the secondary colors — green, orange, and violet — by mixtures of the appropriate primaries. Try for a variety in weight; charging the wash greatly in parts, and letting it be thin and tinted in others. Mix the colors on the moist square — not on the palette.

(2) Pigment Qualities

Use the second half of the sheet to overlay or *glaze* bars of color. Pencil six vertical and six horizontal bands. Paint the vertical stripes in the order shown. When these stripes are completely dry, do the same with the horizontal bands. You now have 15 combinations of two colors, each made twice; once with a color underneath, and once with a color on top.

Do you notice the difference in the way some colors appear when on top? You will discover that stain colors (such as Alizarin Crimson) go through and alter the color beneath them much more readily than the opaque colors, such as the yellows. We will apply this discovery in Lesson 4, Glazes.

Materials:

Stretched sheet, No. 12 brush, and six pigments; a warm and cool of each primary color. Recommended pigments: Cadmium Yellow Pale, Cadmium Yellow Medium, Cadmium Red, Alizarin Crimson or Thalo Red, Ultramarine Blue and Prussian or Thalo Blue.

2

PIGMENT POTENTIALS

Your palette is the keyboard from which each color tone derives. The full palette should have enough pigments to suggest the color spectrum. Now is the time to review your choice of pigments.

Assignment:
(1) Paint a swatch of each of your pigments on the color wheel on the facing page. Keep the brush clean. Use clean water, and enough pigment to produce colors as pure and intense as possible.
(2) Pencil a circle on your stretched sheet as illustrated on page 38, the wheel. Divide it into six equal segments, and label each in sequence with the correct primary or secondary color.

Moisten the entire surface with clear water and then charge in a segment of each of the six basic colors — the same colors you used in Lesson 1. Quickly now, with the clean brush and a minimum of water, blend segments each to the next, making secondary colors.

If the wheel has dried too pale, repeat the operation but first make sure that the under colors are completely dry. In this way you may reinforce the weak or uneven parts of the circle.

Check your work to see that every color is in the right place. A perfect lesson will have no lines marking transition from one color to the next. A well-selected range of pigments will permit each color to appear at near-full intensity.

This experiment may reveal to you the fact that you have too many colors, or that some are redundant. This is a good time to eliminate such pigments from your basic working kit.

Materials:
Stretched half sheet, No. 12 brush, six or more pigments; a compass to make circles.

OPTIONAL EXERCISE:
Modulations to color

Examine the characteristics of each color further by tinting, shading, and graying it as follows:
(1) Identify the color first by making a sample of saturate color, using very clean water.
(2) Then mix a tint by adding water.
(3) Try a shade of the color by adding black to it.
(4) Finally, gray the color by adulterating it with its complement (the color directly opposite on the Color Wheel). If there is no one pigment in this exact position (which is likely) mix adjacent colors to create one.

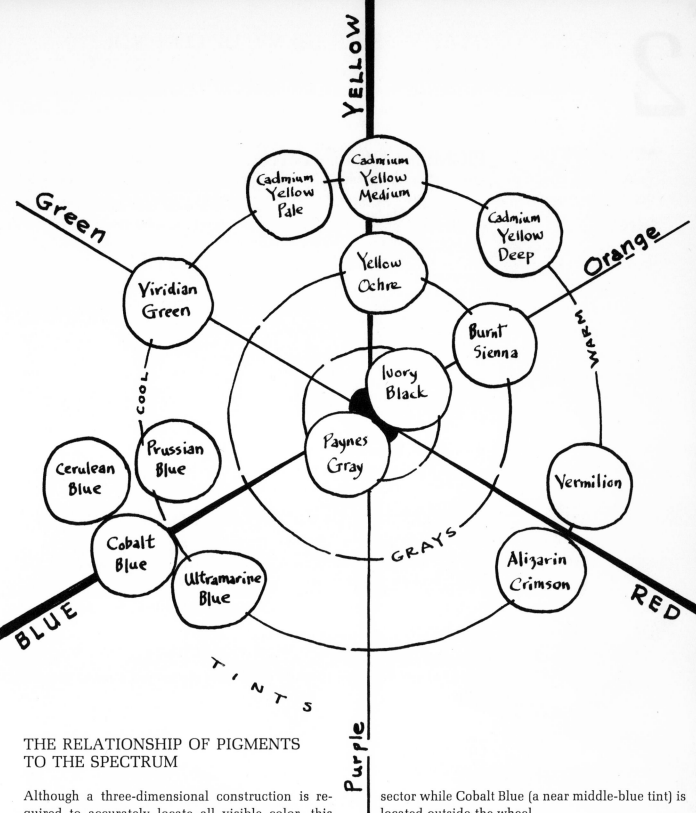

THE RELATIONSHIP OF PIGMENTS
TO THE SPECTRUM

Although a three-dimensional construction is re-
quired to accurately locate all visible color, this
two-dimensional *color wheel* is sufficient for evalu-
ating our pigments in relation to the spectrum. It
establishes a circle of maximum intensity or satura-
tion outside of which are the tints. Inside the circle
are the grays; the middle is black On this wheel,
for example, Prussian Blue (a slightly dark, slightly
green blue) is located inside and towards the green

sector while Cobalt Blue (a near middle-blue tint) is
located outside the wheel.

*A caution: No two tubes of paint will be exactly the
same. For example, Burnt Sienna may vary from
gray-orange to gray red-orange. The pigment loca-
tions indicated are for guidance only. Let your eye
be the final arbiter.*

FLAT WASHES and VALUE CONTROL

3

Fundamental to watercolor is the *wash*, a controlled deposition of pigment on the paper or a segment of it. When you must be sure of the result, and when boldness and pattern are at a premium, use the wash!

Mastery of the techniques of flat and gradated washes is fundamental to good watercolor and will establish a basis for later experiments in wet-into-wet, drybrush, and line. This assignment is devoted to learning to control a *flat wash* — an even, unmodulated tone — and to exploring an incidental phenomena, *granulation*.

Assignment:
Divide the sheet into four rectangles.

Examples 1, 2, and 3 (opposite). Mix a pan of light gray value, dip a full brush-load and start a bead of color across the first section, working from the top down. Keep dipping and carrying the color to this bead as you work down the sheet. The board must remain at the constant angle shown; too steep a slope will cause the color to slide to the bottom of each stroke, making jumps; too flat will not make the water *pull* the pigment over the sheet. For successful wash painting, the sheet must not buckle, sufficient water and pigment must be ready on the palette — and **the painter must have patience.** Do the same with mixtures of middle gray and of deep value, as shown.

Example 4. The granulated wash is laid in the same way as above, using any pigment with body — not a stain color. Make the color fairly heavy and pull it evenly across the sheet. Immediately lift up the surplus bead and tip the board in the opposite direction and back again, like a miner panning gold. The pigment will tend to settle into the hollows of the textured paper, giving the granular look shown in the sample. A heavily textured, hard surfaced sheet promotes this effect more than a smooth, soft surface.

Materials:
Stretched sheet, preferably rough finish.

15°

Don't hump over and paint with your nose. Avoid tilting the board more than 15 degrees.

No!

Flat Washes

1 2 3

NOTES ON TECHNIQUE

While a wash is being run, the board should be tilted at an angle of about 15 degrees. To keep the board steady, prop it with any handy object; don't try to hold it in your lap.

Some papers will accept washes more readily than others, and some are inclined to pin-hole (leave tiny white, uncovered spots) during the first wash. If emphatic brushing does not eliminate pinholes, try a drop of detergent which has a moistening agent in the formula.

Shake out the brush immediately after the wash is run and use it to pick up the overflow of paint at the edges of the wash and in the tiny groove between the paper and the stretch tape. This will speed drying and eliminate any possibility of "runbacks" or "curtains."

Each stroke overlaps the preceding one. No wash should be run until the previous one is dry. If the day is moist and the wash is slow to dry, alcohol may be added to the water. One may even use an electric hair dryer to speed the process.

4

Granulation

Stretch the paper to avoid hills, valleys—and puddles.

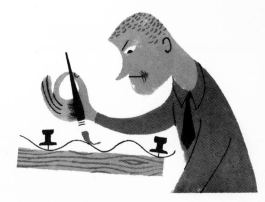

4 GRADED WASHES

No other medium permits the easy modulation from light to dark or from one color to another that the watercolor does. Much of the sense of movement, liquidity, and "bounce" which characterizes the medium is caused by these transitions — and it is to be encouraged. This lesson explores the ways to control such modulations through *gradation* and *interchange*.

Assignment:
Pencil-in two rectangles, making one somewhat larger. Divide the larger shape into thirds vertically.

(1) **The gradated wash:** Commence with a bead of the deepest color at the top of the sheet, pulling it downward a stroke at a time. As the brush dips pigment, more water is stirred in, tinting the color. The bottom of this wash should be clear water. Now, lift this surplus with the brush and let dry. Remember to keep the board tilted 15 degrees, and to keep the brush handle high and the brush well loaded so that an even bead of color is left with the stroke. Lap each stroke about one-half, pulling the bead slowly downward.

(2) The interchange is done across two-thirds of the larger rectangle, with a wait for drying. Then turn the board around and on the other two thirds run a second gradated wash. If you achieve a perfect taper, the overlapping middle section will be a uniform gray from top to bottom.

Gradated washes, a demonstration from the moving picture "Watercolor Landscape" by the author. Courtesy Allend'or Productions Inc.

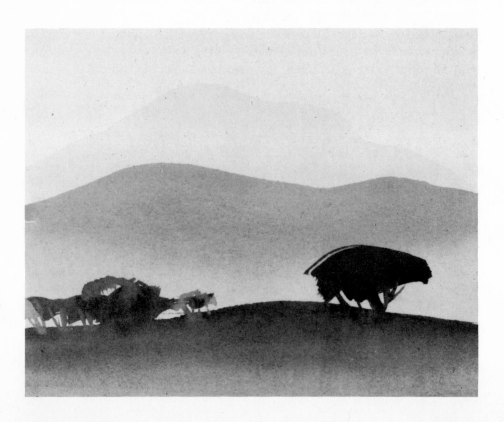

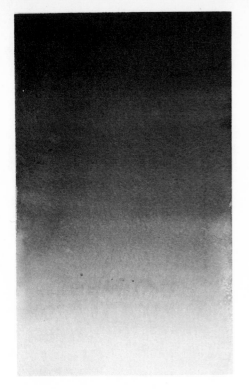

A gradated wash

An interchange

OPTIONAL EXERCISES

Once the rhythm of wash-running is mastered — and it comes quickly with practice — try cutting around white shapes as in a painting. Here are three exercises that can be repeated and varied. You may use cheap, unstretched paper for them.

(1) Outline two or three block letters with a pencil, and then pull a flat wash of any one color around each symbol — jumping the whites and keeping the several beads all progressing until they join at the bottom.

(2) The same as above, but *gradate* the wash, increasing the mix of water with each stroke.

(3) Tilt the board to elevate a corner and run a gradated wash *diagonally* around the design.

Materials:
Same as previous lesson.

5 GLAZES

We have discovered that such colors as Alizarin Crimson and Prussian Blue sink into or stain the paper — and any pigments that may be under them. Other colors such as Yellow Ochre and Cobalt Blue are more opaque. They have body and stay on top. Using these more opaque colors thinly in a wash makes a transparent veil. This is the *glaze*.

The glaze is used to create an optical effect. For example, a glaze of Cobalt Blue over a purple-brown distant mountain duplicates the effect that nature creates by putting sky between observer and mountain.

Another use for the glaze is to pull colors together by this over-wash of one color. It overcomes the rawness of unrelated colors by giving each one something in common with the next.

In this lesson we use an interchange of gradated washes to create an even, almost imperceptible change of color and value while exploring the optical effects of glazing.

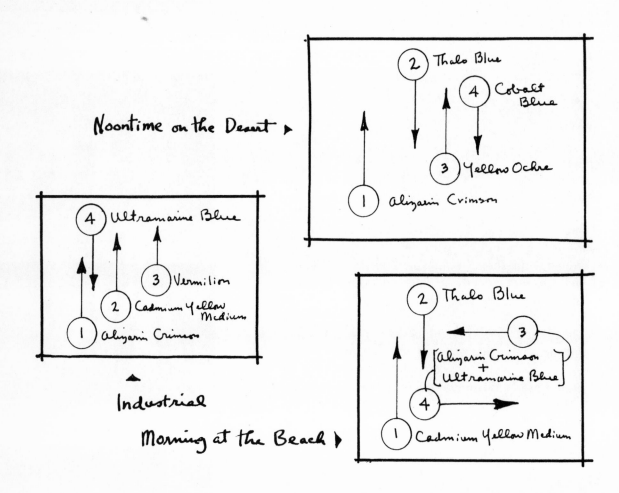

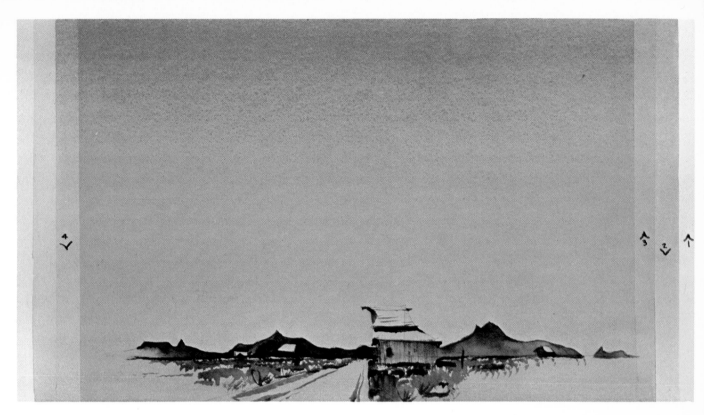

NOONTIME ON THE DESERT

INDUSTRIAL

SKY in the INDIRECT [Glazing] TECHNIQUE

MORNING AT THE BEACH

Assignment:

Try at least two of the skies illustrated. Run each wash from dark to light, turning the board around if necessary to make this easier. Be sure the wash is dry before laying a glaze over it. The warm ground light will be the lightest of tints — unless you are doing Los Angeles smog! You may add a strip of dark foreground when all is dry; it helps to make the sky seem more luminous.

Work for the same qualities of smoothness as in the interchange problem of the last lesson. When you are satisfied that you have mastered these skies, make up some combinations of your own. There are hundreds.

Remember to paint the stain colors first — and the heavier, body colors on top!

Materials:

Stretched paper, No. 12 brush.

SUGGESTIONS FOR ADDITIONAL GLAZE COMBINATIONS

INDUSTRIAL SKY (A variation on the example, preceding page)
 Up: Burnt Sienna. Down: Ultramarine Blue.
TYPICAL MORNING
 Up: Cadmium Yellow Pale. Down: Cobalt Blue.
EVENING
 Up: Alizarin Crimson. Down: Thalo Blue.
 Up: Vermilion. Down: Ultramarine Blue.
CLEAR DAY
 Up: Alizarin Crimson. Down: Ultramarine Blue.
 Down: Cobalt Blue.
TEXTURED SKY
 Up: Alizarin Crimson. Down: Prussian Blue.
 Then, a flat granulated wash comprised of Ultramarine Blue + Ivory Black + Viridian Green.

Don't attempt to run a large wash with a small brush.

As you become more familiar with the indirect (wash-on-wash) technique you may want to vary the direction of gradation. For example, the sense of sunlight from the left side of *"Morning at the Beach"* (page 47) is intensified by two opposed gradated washes run transversely from the sides of the sheet. To run these washes, turn the board so that the sides are to the top and bottom.

Diagonal washes can contribute both feeling and movement to the sky shape. Such gradation is accomplished by raising a corner of the board and running the wash slant-wise.

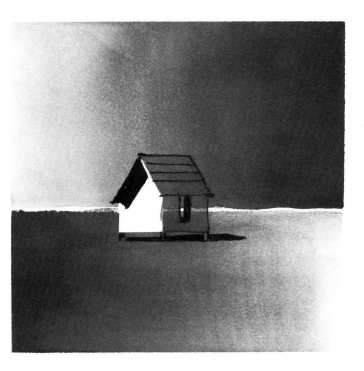

Transverse gradation

Diagonal gradation

Use a clean palette and mix enough color in advance to cover the whole area.

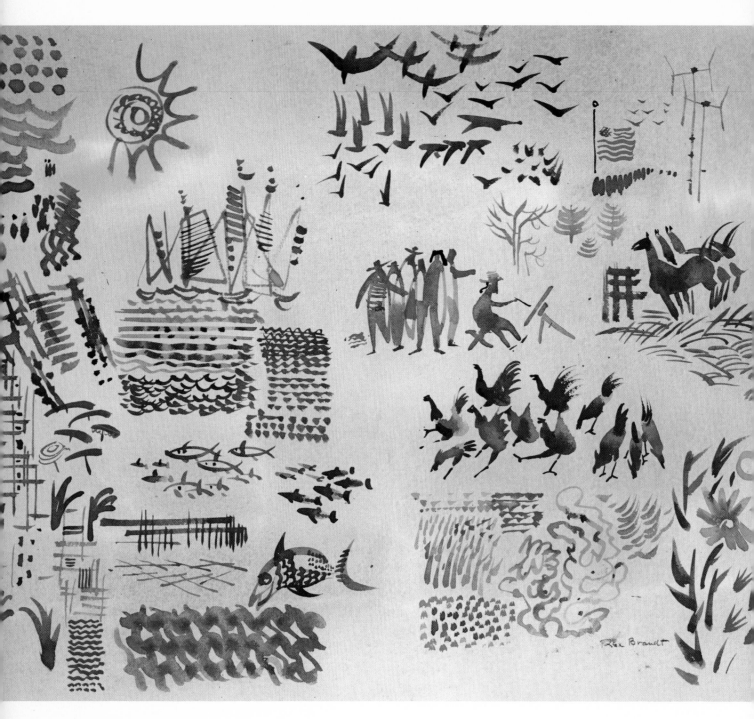

A BRUSH LINE "SAMPLER"

BRUSH LINE

The Shorthand Language of Watercolor

If ever personality and individuality are lost, I shall lay the blame on the ball-point pen. These devilish little tools reduce each enthusiastic push, tentative jab, or pensive gesture of the writer to sterile linear conformity. If the watercolor brush is nothing else, it is the rebellious negation of all such monotony. When you jab with a brush, it leaves a big splotchy record of that jab; when you tickle the surface, it stays tickled. The brush is the expressive companion of the painter's heart.

When we first hold a brush in our hand, we are confused by the flexibility of this pliant tool. Yet no adult is without hundreds of hours of practice with his writing hand, ball-point pens notwithstanding.

The brush's potential for fast, repeated symbols and figures makes it a most useful tool for the quick sketch and the casual decoration. In some cases line alone does the job, in other cases, washes or wet-into-wet is used as support. Unsupported brushline may be thin, but it does have variety, expressiveness, and an epigrammatic immediacy. It is useful for complicated subjects and repeated motifs such as crowds of people or masses of cars, and it combines nicely with wash and wet-into-wet.

The Chinese and Japanese letter and paint fluently and beautifully with the pointed brush, held high, so that by varying the downward pressure the thickness of line will change. This gives a most expressive quality to their letters (or hieroglyphics). An able Oriental "penman" may spend years developing this sure touch. Most American watercolorists are poor equals, largely because they do not take time to practice. This lesson only hints at the rich possibilities.

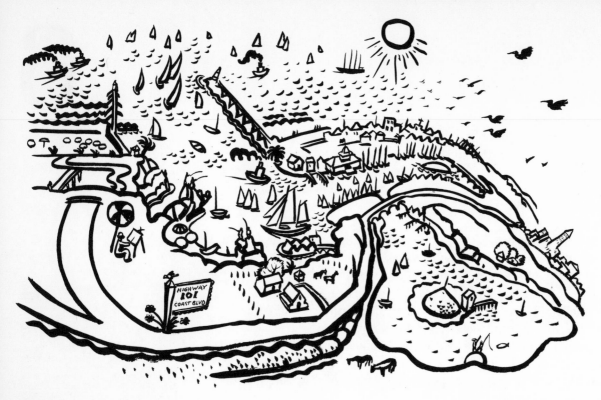

DECORATIVE MAP, Phil Dike

EXAMPLES OF BRUSHLINE

Phil Dike's cartograph of Newport Harbor demonstrates the brush's potential for epigrammatic symbols. The original is about eight inches long.

Charles Burchfield's brush patterns are both decorative and emotional, suggesting heat or sound, trees and grasses in the wind, and the flight of birds.

Raoul Dufy's calligraphic brushline grille is like the melody of a song. It provides counterpoint to bars of free color.

AUTUMN WIND, Charles Burchfield Collection Springfield Museum of Art

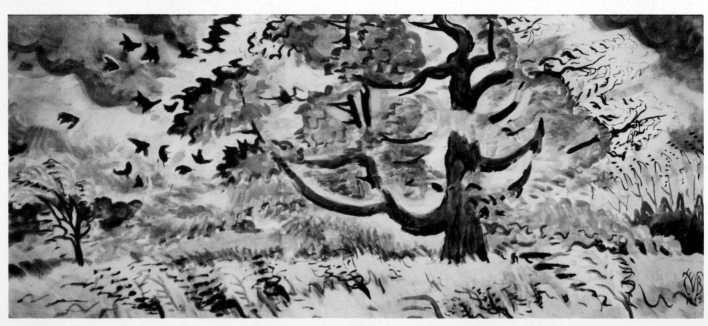

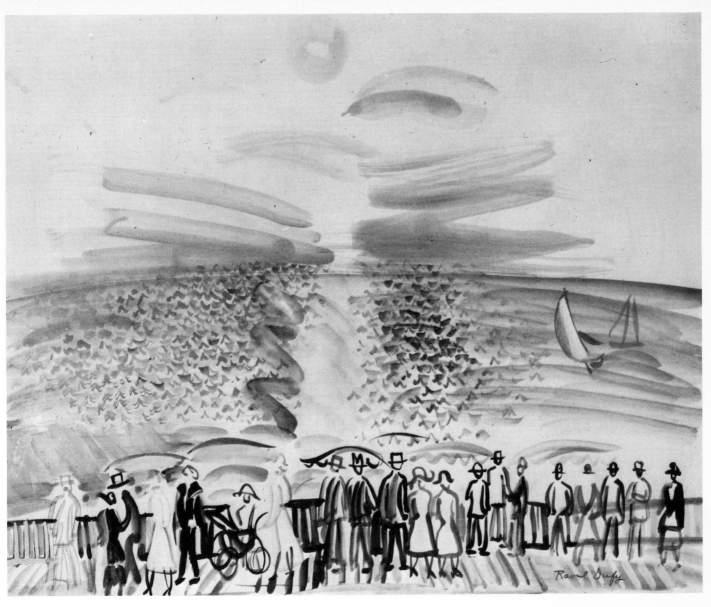

REFLECTIONS OF SUN AT THE SEASHORE, Raoul Dufy Collection Los Angeles County Museum of Art

Chinese hieroglyphics

HANDLING THE BRUSH

Like a pointing finger, the brush — ultimate extension of the hand — leaves a track with each gesture. Affirmative wide lines record pressure; thin lines indicate restraint. How the painter feels, what constitutes the condition of his health, what hopes and sorrows are his lot — all these are revealed.

If you are just starting to paint, I recommend no change of grip or rhythm from your pencil and pen habits. It is true that the Oriental holds his brush more nearly upright with a unique grip that is very responsive to changes of pressure; yet the Occidental ways can be modified quite easily to accomplish the same effective results. Just drop the wrist slightly and remind yourself that you wish to keep the brush at right angles to the surface of the paper. It works with very little practice.

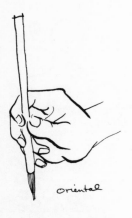

Oriental

For a better brush line, I recommend the following:

(1) Use a well-pointed brush such as a new No. 12 red sable. If your No. 12 is too worn, try a less expensive, small red sable round. My favorite is a good quality No. 8. The smaller the brush the cheaper, but it will carry less paint and the painter must interrupt his strokes more often.

(2) Do not practice calligraphy on too rough a surface. A smooth or cold-pressed surface is easier.

(3) Keep the body independent of board and paper so that all action is transferred to the stroke, not to the board.

(4) First, keeping fingers, wrist, and arm rigid, try strokes in which you paint "with your knees." Allow the *body* to shift weight as you stand. This will make large, positive lines.

(5) Next, rotate the upper *arm and elbow* only, creating controlled arcs of broad radius.

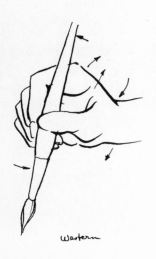

Western

(6) Try the *wrist*, twisting or revolving it in a series of "flip-flop" movements. It helps to count, or tap your foot with a definite rhythm.

(7) Finally, allow the *fingers* to clench in a series of pinching or twisting movements. The products of these strokes will be the smallest, and doubtless, the most cramped textures you will have on the sheet.

(8) Practice these strokes until they are automatic, and you feel a sensuous pleasure in each series of movements.

(9) Next, with each of the above exercises, try a 1-inch red sable flat, then a very small brush, and finally a large, worn brush. Each brush will make a different calligraphic track.

(10) To economize, use newspaper for practice, preferably the "Want Ad" sections, which are a more uniformly gray in the absence of pictures. Use a brilliant color such as Prussian Blue for legibility.

You will discover that all kinds of linear qualities flow from the brush tip. When using a pencil, you struggled for variety; now, using the brush, you work for control and uniformity.

Repeat each stroke many times rather than trying for variety. It creates a richer effect to do a row of pine trees than one pine tree, a clump of bamboo instead of one stalk. Think of *texture* rather than *pattern* as you work.

Texture vs. Pattern

Many painters do not differentiate between pattern and texture, and yet the distinction is important to all painting. *Pattern* is formed by a figure or symbol which may be regarded as a unit. *Texture* results from an accumulation of similar units repeated so often that they lose their individuality. When a stroke is repeated seven or eight times, the eye ceases to regard each stroke separately and instead sees a new unit, consisting of the whole group, as a *textured figure.*

This distinction is important to the landscape painter because often he is impressed by one, yet paints the other. For example, if the texture of a field of wheat is indicated with only five or six strokes, the result is wormy or busy because each stroke is viewed as a separate figure. The addition of a few more similar strokes will give the effect of texture and solve the problem.

Also avoid unnecessary outlining with the brush. A textural area is a shape and seldom needs the restrictions of a fence-like line. The same is true of an area of color or value. To separate adjacent areas with line is to remove some of the drama of contrast.

Practice, practice, practice!

A student in China or Japan has daily drills with the brush for many years before he is considered capable of painting with it.

In my 15-week watercolor-technique course we cover the subject in one day. I am told that this is one day more than most classes devote to the subject! Certainly the ability to speak fluently assists in communication of verbal images. In the same way, I think that the ability to use the brush fluently promotes better painting. So practice, draw, and sketch with the brush.

FIRST EXPERIMENTS WITH THE BRUSH

When you bought your first brush you were probably unaware that you had a machine capable of creating as many characters as a typewriter, and with almost the same speed. This lesson explores the rich potential of the watercolor brush, and shows you how all your experience with pen and pencil may be incorporated immediately to create textures and symbols.

Using plenty of cheap, porous paper and a well-pointed brush, commence your experiments by duplicating your handwriting. Do rows of such letters in the alphabet as *e, i, l, m, n, o, u, w,* and *x.* Try numbers — a series of 1's, 3's, 6's, 7's, and 8's. Next, change the angle of brush to paper. You will discover new patterns.

Assignment:

Complete one or more pages of textures for each of these increasingly complex actions: *Stampings, Single Strokes, Compound Strokes,* and *Inventions.* Don't try to copy. Instead, gesticulate, pat, jab with the brush, duplicating familiar motions of hand and arm.

Stampings: These are the simplest brush figures, requiring only an ability to apply paint to paper. Start with them.

Choose any one brush. Load it with paint and press it repeatedly to the paper, holding the handle at the same angle for each stroke. Try again, but change the angle of the brush.

Try another series, first modifying the bristles by squeezing them apart to make a fan-like crescent shape.

When you have exhausted the potentials of one brush, try another. When you have discovered the latent patterns of all your brushes, proceed with Single Strokes and Compound Strokes as discussed on the next pages.

Materials:

Twelve or more sheets of absorbent paper, such as Japanese Rice paper or news blank; one or more brushes, and any one dark pigment.

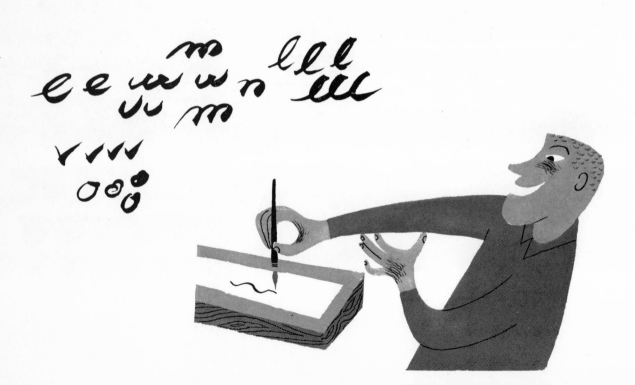

Find a comfortable position; hold the brush high.

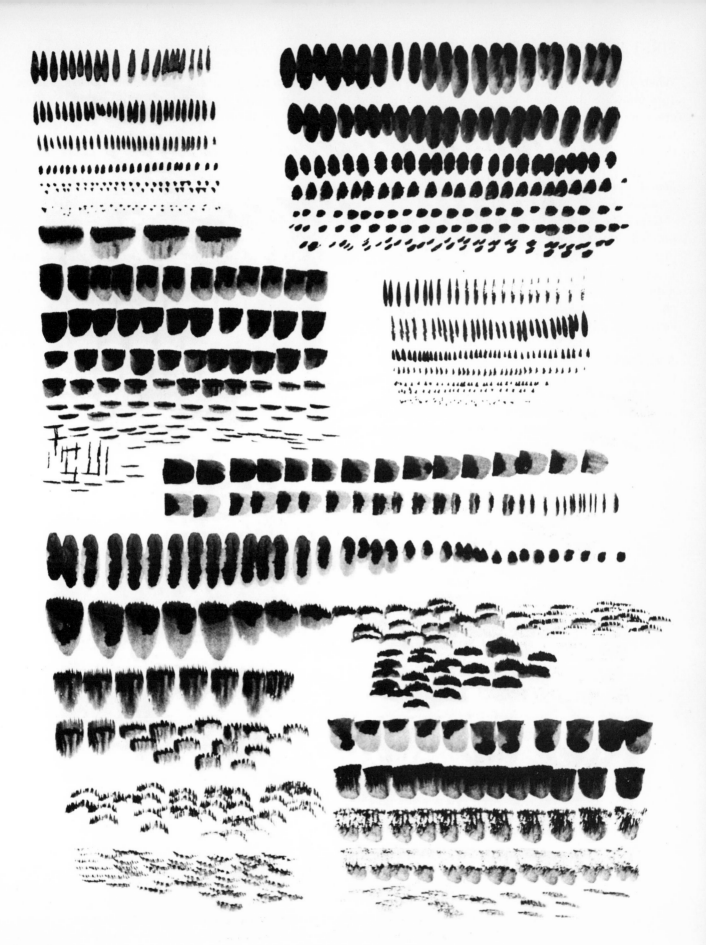

Stampings

57

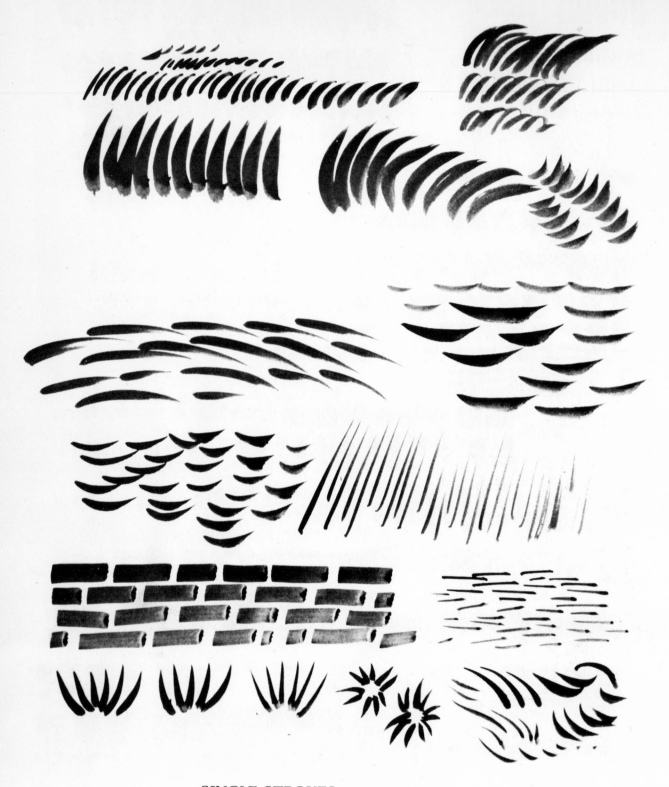

SINGLE STROKES

When we add a second muscular movement to the stamping action, the result is a line as in making the figure 1 or the letter c. It may be straight or curved, depending on the action of fingers, wrist, and elbow. It may be thicker at one end, stamp and then a lift — like an airplane taking off — or thin to thick — like an airplane landing.

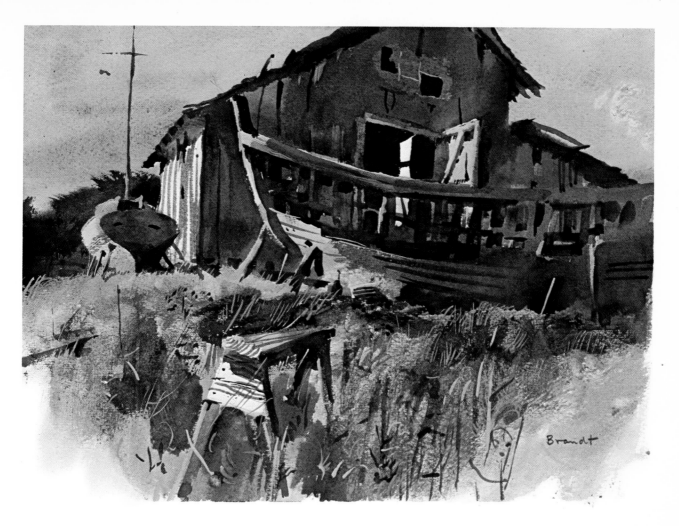

"ARNIE'S BOATYARD" Informal texture in the manner of the American illustrators.

INFORMAL vs. FORMAL TEXTURES

"ARNIE'S BOATYARD" Formal (decorative) texture
in the manner of the French colorists.

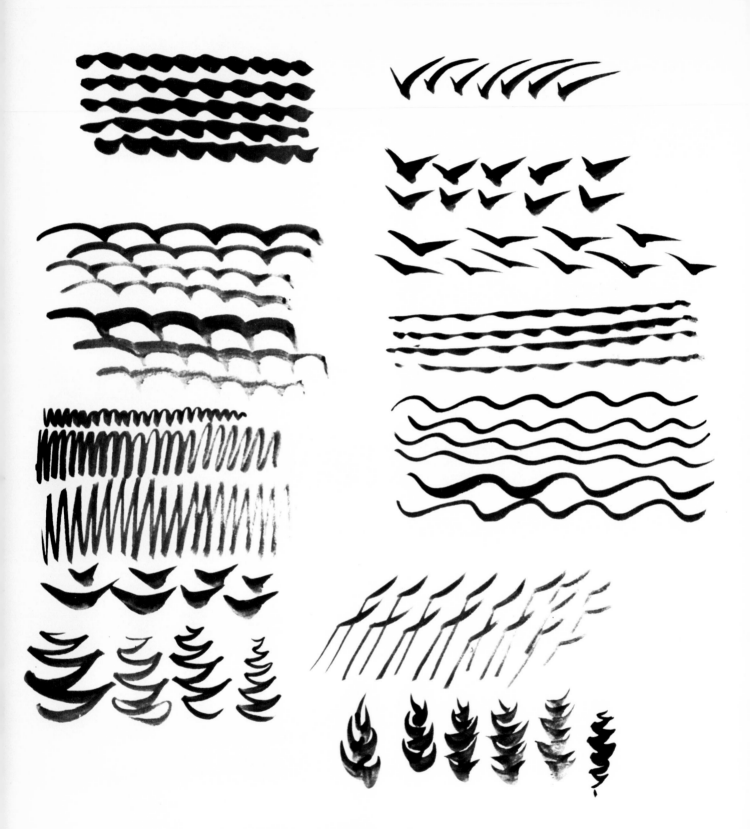

COMPOUND STROKES

Two or more interlinked muscular movements, as in writing the letters *w* or *m*, exemplify the compound stroke. They fuse as one figure because the calligrapher's hand and mind feel them as one operation. Keep them this way and they will preserve that easy, continuous look.

COMBINATIONS AND INVENTIONS

As you experiment with brush calligraphy you will make accidental discoveries. If the strokes and stampings are applied to wet rather than dry paper, quite a different set of textures ensue; or hard, stamping motions may make rough-edged explosions of pattern (facing page). And yet the same heavy pressure combined with a repeated twisting motion of the wrist creates sea-swirl patterns.

Other applicators such as the finger tips, the edge of a piece of cardboard, the tip of a cigarette filter, etc. augment the glossary of textures.

These examples were produced by one student during one lesson and are typical of what you may discover:

(1) Drybrush, hooked stroke.

(2) Loaded flat brush on moist paper, then pointed brush accents.

(3) Wavy drybrush line, cross-hatched.

(4) Drybrush cross-hatch.

(5) Half-dry brush stabbed downward and then twirled between the palms.

(6) Drybrush on moist paper.

(7) No. 12 brush, pressed flat with fingers and then drawn in short strokes.

(8) Well-loaded brush on wet paper.

(9) Finger-print chain.

(10) Drybrush twirled back and forth between palms of hands.

1

2

3

4

5

6

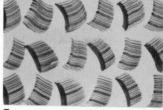

7

8

9

10

7

BRUSH LINE COMBINATIONS
Make symbols and hieroglyphics

Because brushlines vary in width — in contrast to pencil, chalk, or pen line — they suggest living things such as bamboo leaves, tapering tree branches, animal legs, or bird wings. By combining one or more kinds of strokes, the imagery can be extended to symbolize almost any object, thus creating a language of pictographs or hieroglyphics.

On the facing page, for example, we see variations on the cross-hatch, combining two sets of single strokes; the wave-line pattern suggests a water surface while the diagonal, darting strokes make a shingle or brick texture. The flowers are the product of stampings (petals) and single strokes (leaves). A cluster of single strokes (bottom of the page) suggests conifers or, if the strokes are all aimed at one stem-like point, a flower or pod shape.

"Shall I start at the thick end or the thin end of a stroke?" is a frequent question to which there is no best answer. I usually start with the light (thin) end of the stroke and stab downward toward the heavy (thick) end. This has a positive, declarative feeling, and I can control the line better. It is similar to underlining. On the other hand I create a much more exuberant feeling if I stab first, and then lift as I pull the brush away. Flags in the wind, for instance, seem better painted this way. Let your feelings guide your hand.

Don't be afraid to use dots for texture, or little clod-like collections of fat points made by repeated jabs of a medium-size brush to animate a bare foreground.

When you delineate tree skeletons, be sure that you preserve a sense of *taper.* Make the trunks largest and then progressively reduce the size for limbs, branches, and twigs; otherwise, the tree will have a very clumsy and unhealthy look.

Where do we find ideas for brushline symbols? From nature, from experimentation, and from others. Investigate them all, using a dozen sheets or more before proceeding with this lesson.

Assignment:
Make a half-sheet "sampler" of textures and symbols similar to the example on page 50. Experiment with color-on-color by first moistening the entire sheet and painting a soft-edged checkerboard of tone and color. Let it dry. Then apply some of the textures and hieroglyphics you have discovered.

Experiment with color by changing pigments from time to time, and by charging accents into the strokes while they are still wet. For example, note how red and green have been blended into the brown shapes of chickens (page 50).

Materials:
One or more brushes with a good point, a full palette, and one half-sheet of stretched smooth-surfaced watercolor paper.

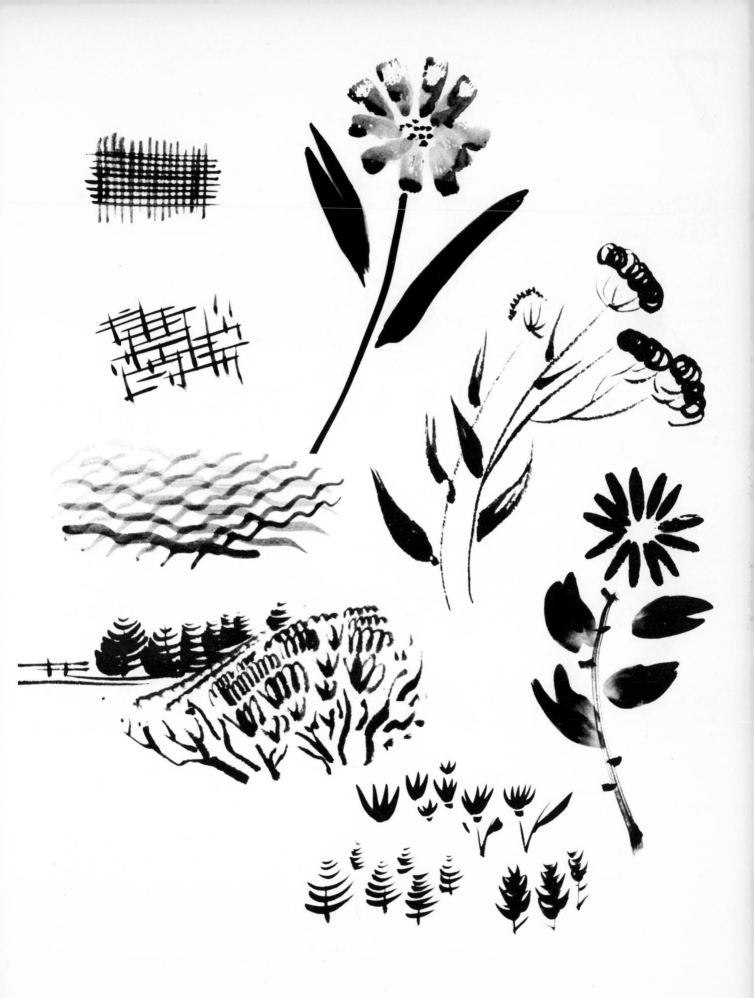

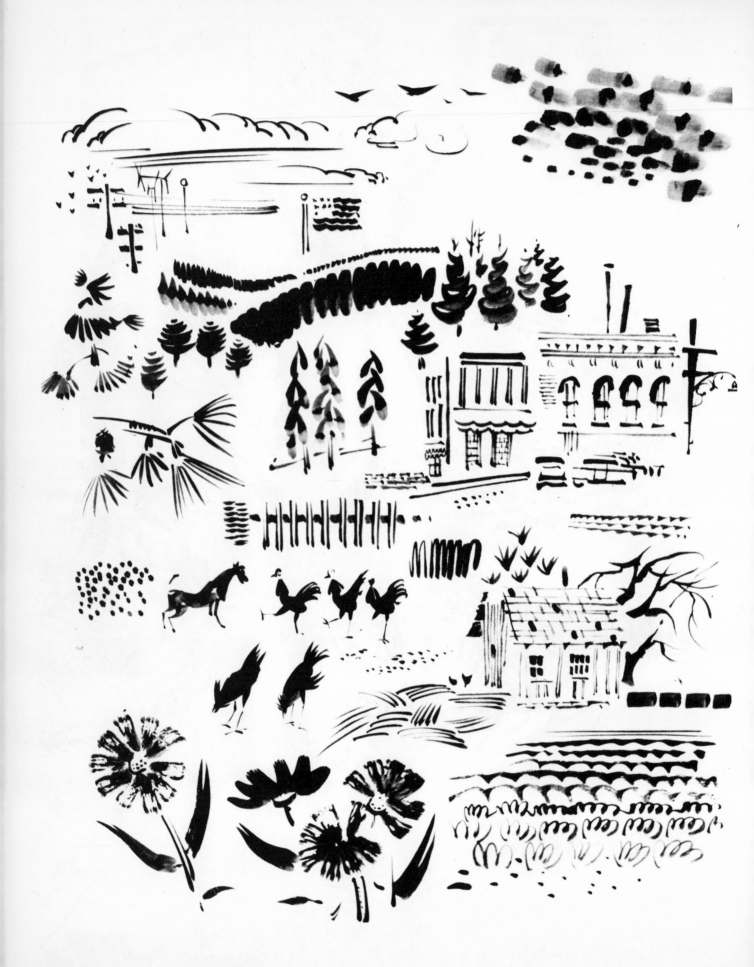

64

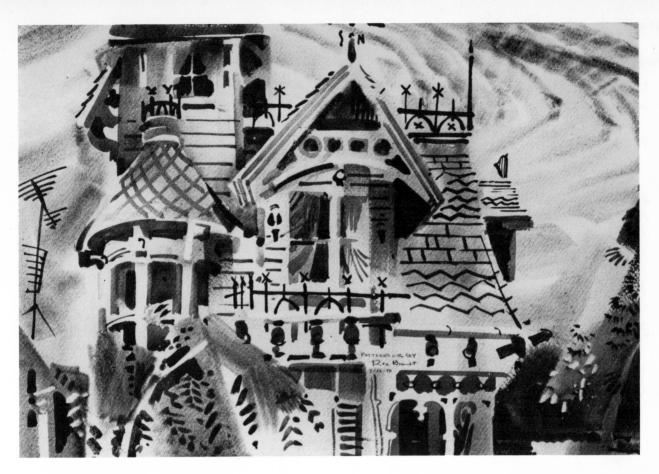

PATTERNS IN THE SKY, 13½″ x 20″

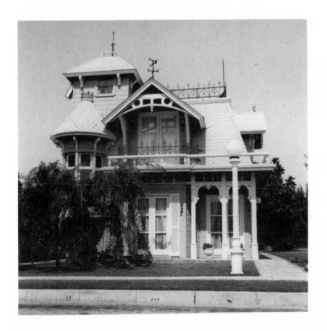

Photograph of subject

The Victorian house, top and left, with its many intriguing textures is a good subject for calligraphy. Repeated single strokes give richness and rhythm to the Japanese panel painting, right.

8 DRYBRUSH

For controlled modeling, for texture — and finally — to build up deep darks without muddiness, try drybrush. Illustrators favor this technique because, although slow, it is sure and strong. Charles Burchfield used drybrush to build deep yet luminous tone. It is better than too many repeated washes for this purpose, since it keeps the color open.

Two techniques are used generally:

(a) *Texture from the bristles: Drybrush Tip.* Drag the bristles over the smooth paper, using little water and a good deal of color. Cross hatch the strokes to weave the color together.

(b) *Texture from the paper: Drybrush Scumble.* Drag the side, or heel, of the brush over rough paper, using more water, and you will produce a rough texture, reminiscent of an oak tree or a dirt road.

Assignment:

Choose a simple solid still life, such as an orange or a book. Make one painting on smooth paper with drybrush tip — another on rough paper, dragging the brush heel. Build the drawing up slowly from lighter to darker gray and then to black. Allow a minimum of one hour for this exercise, working around the sheet in such a way as to permit each stroke to dry before crossing it with the next.

Materials:

One rough sheet and one smooth sheet, preferably stretched, Ivory Black, and a No. 12 brush — the brush will work better if it is rather worn.

CORRAL, Phil Paradise

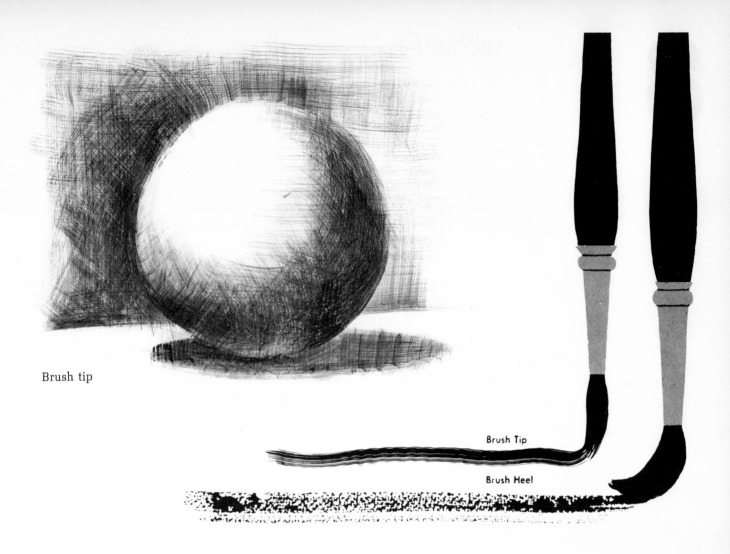

Brush tip

Brush Tip

Brush Heel

Brush-heel scumble

9

WET-INTO-WET

Now we are ready for the third basic technique — the most exciting and perhaps the most risky of all. The *wet-into-wet* technique is sometimes called the *feather-edge* or *direct* technique. It is spontaneous, spongy, and spectacular! The wet surface of the paper is the palette while the water is the spring and the blender.

When the painter puts wash-on-wash without waiting for the undercolors to dry, he is painting *wet-into-wet*. The feather edges that result are soft and juicy, but the flooding of color-in-color and the "curtains" that may occur are often distressing. How to make the most of the fluidity of the method, and at the same time avoid the complications, is a challenge to the watercolorist.

When to use it:

(1) As *underpainting*, establishing a soft-edged, pale undercolor on which subsequent washes may be laid. An example is the pale violet-brown undertone for green trees, which reduces the cold look of unrelieved green paint.
(2) For *soft-edged subjects*, such as clouds in the sky (the subject of this lesson), surf and foam, and rolling, grass-covered hills.
(3) As a *mode of expression*, as in the paintings of George Grosz and Lyonel Feininger. The explosive, feather-edged areas boil with life — although they may be somewhat wanting in clear shape.

How to control it:

(1) Clue to control of the wet-into-wet technique is *speed*. Speed comes with confidence and knowledge of the subject.
(2) Control is improved by the following procedure: Wet the sheet thoroughly before painting, and keep it wet as long as possible by working from the large, gray areas, first, to the small, dark areas, last.

Avoid excess water in the brush strokes. The water should be on the sheet before the color is applied. Think of wet-into-wet as *drybrush painting into wet* (see illustration on the facing page).

Opposite:

ICELAND POPPIES, 20″ x 13½″, Joan Irving

An excellent example of textural control commencing with the first soft wet-into-wet tones on the background, then whisking darker pigment into the flower shapes, becoming drybrush as the surface sets up. Then the artist ran the gradated washes of sky.

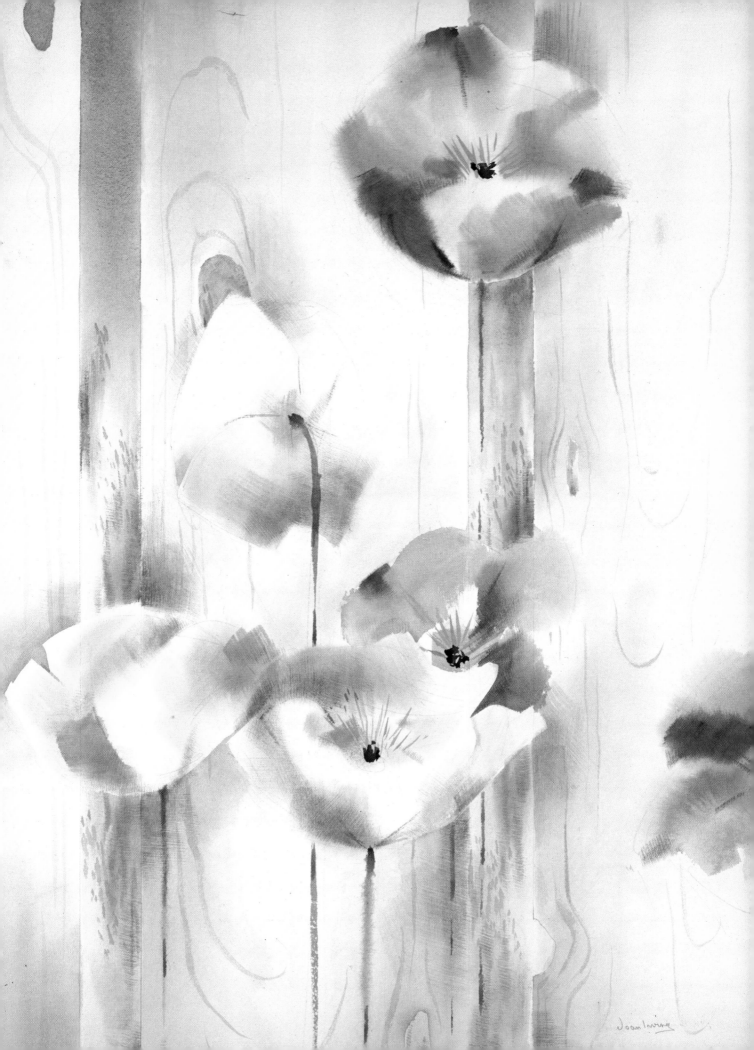

VICTORY OF THE SLOOP MARIA, Lyonel Feininger
Collection Los Angeles County Museum of Art

EXAMPLES OF WET-INTO-WET

If the poetry of transparent watercolor is realized in the crystalline wash-and-line paintings of Cézanne, its dynamic and expressive potentials were first manifested in the explosive wet-into-wet by painters of the *Bauhaus* and *de Brucke* groups of early twentieth-century Germany. The works of Emil Nolde, Paul Klee, Karl Schmidt-Rottluff, Max Pechstein, August Macke, and Oscar Kokoschka are examples. Lyonel Feininger, George Grosz, and John Marin were among Americans to adopt some of the ways and attitudes of these Expressionists, as did Tom E. Lewis and Maurice Logan on the West Coast.

CALIFORNIA WINTER, Maurice Logan

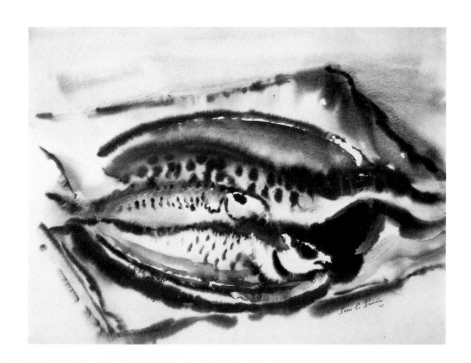

THREE FISH IN A PAN, Tom E. Lewis
Collection San Francisco Museum of Art

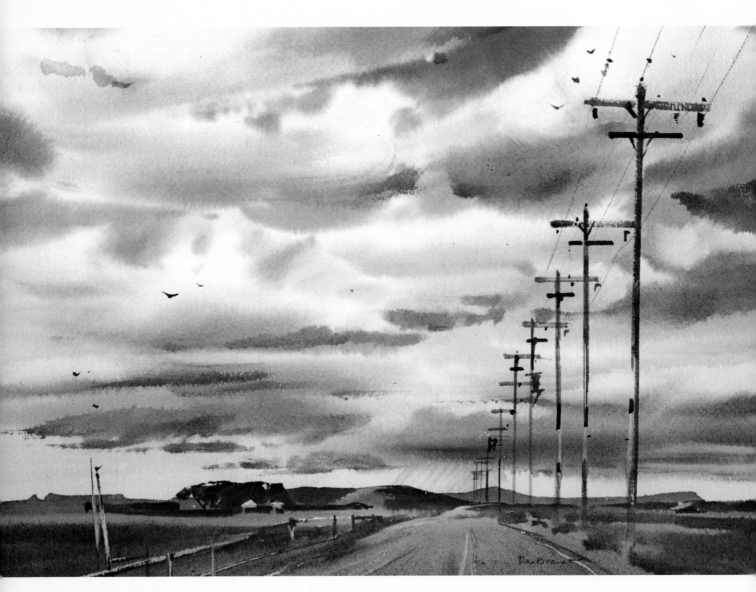

TYPICAL DAY WITH CLOUDS, 12"x18"

CLOUDY SKIES

No subject invites more delightful and rewarding experiments with the fluid, soft-edged method of wet-into-wet than clouds and skies.

When you paint them remember that clouds conform to the laws of perspective; the biggest, softest ones are nearby, overhead, while the smaller, firmer-edged ones are toward the horizon. Their undersides reflect the land or sea over which they rest and may, therefore, be different colors. And they cast shadows on each other. These shadows are darker than the shade side of a cloud.

Of all the kinds of clouds, the long, cigar-shaped stratus are the easiest to paint. Try these shapes first, in different combinations of colors: Smoky browns against blue sky; red sunset clouds against a yellow sky; black clouds before a red evening sky.

Assignment:
Paint a cloudy sky with blue sky patches showing through, similar to the example on the facing page.

With the sheet wet, start at the top, working down toward the horizon. The board should tip **downward** toward the top, since we want the farthest clouds nearest to the horizon to be a bit drier than the large ones overhead. First, paint the warm undersides of the clouds gray modified by the reflected colors of the surfaces they pass over.

Since the nearest clouds are bigger and softer, and the farther away they are, the smaller and sharper they become, paint the near ones while the paper is still very wet. Paint the sky patches in the same order, remembering that the sky is not the same color from top to bottom (Lesson 5).

Finally, paint a dark foreground; this darkness will make the sky seem more luminous. Try a number of these skies and attempt to pick a good day to observe cloud effects — they're never the same.

Materials:
Rough paper, No. 8 or No. 12 brush, palette of six or more colors.

TECHNICAL SUGGESTIONS

(1) Spend as much time as possible in the pre-moistening of the sheet — the more you soak it, the longer it will stay wet. Of course on a humid day one must avoid too lengthy a soak if the sheet is to dry within the estimated painting time.

(2) Because there is always some low point to which water runs, I prefer a slight tilt (about an inch) so that I may anticipate the fact that the sheet will dry first at one end and I can schedule my washes accordingly.

(3) Wet-into-wet is difficult to manage when painting outdoors. Either the day is too dry, and the painting interval too short; or the day is too moist, and the sheet never dries. If you essay the technique outdoors, try to protect the board from both sun and dew while painting.

(4) Avoid buckling or dimpling the paper. If you do not use a stretched sheet, this is accomplished by pre-soaking, placing the thoroughly moistened sheet on a non-absorptive surface such as glass, linoleum, or a shellacked drawing board. The very heavy sheets (300- or 400-pound) can be used without stretching.

less than 1"

First try: Stratus clouds

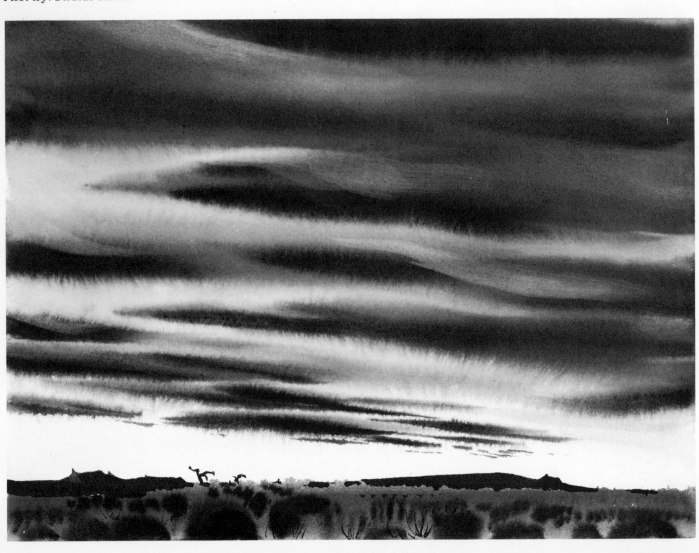

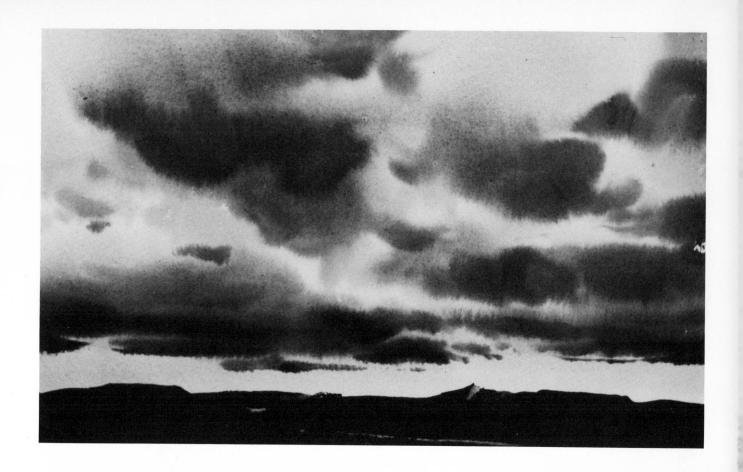

(5) Remember that each bit of color you carry to the wet surface is helping to keep that surface wet. Therefore you must work from the big background areas up to the small areas at the center of interest. You will find yourself with a lot of dry paper if you reverse this process. The lessons in wash planning are important preparation for this kind of painting, as they stress the development from the large, negative shapes to the sharp, positive shapes at the center of focus.

(6) When used in concert with other techniques, execute the wet-into-wet passages first. Once the sheet has been partly covered with color and allowed to dry again it is no longer uniformly receptive to water, and the control of the moist surface becomes unpredictable.

(7) Think of wet-into-wet as "drybrush-in-wet." Get the moisture into the sheet before painting. Then use short-bristled brushes, carrying as much paint and as little additional water as possible with each stroke.

(8) Rough paper works best, as water settles into the pores and does not run too much.

(9) Drying time may be extended by adding a few drops of glycerine or honey to the mix water.

(10) *Speed* is the final caution. Don't shilly-shally! Once the sheet is moist keep it "all going." Brush into any area that threatens to dry before the painting is worked up to the desired value and color. When it finally starts to set, leave it alone! Don't even change the tilt of the board until the whole passage is dry.

THE PLASTIC POTENTIAL OF
WET-INTO-WET

As you explore the wet-into-wet technique you will make some happy discoveries. For example, color can be charged into color as heavily as mud and yet, unlike wash-on-wash, each grain settles into place and the result is seldom muddy. You will also find that although some definition is lost as shapes blend into shapes, there is a compensatory increase in cohesiveness.

This malleability has a sensual appeal comparable to moist clay. Like the clay, it invites modeling. For example, I love to use wet-into-wet for California's rolling hills, for curving sails, and for plump-figure studies.

Here is an exercise that will introduce you to these plastic pleasures. Try it after you have done a few cloudy-sky studies.

Select a single solid subject such as a human model, a sculpture, a piece of gnarled driftwood, a worn shoe or glove. Paint its shape (silhouette) on a quarter-sheet of rough, stretched watercolor paper, using Yellow Ochre. Wet-blend into this shape with Burnt Sienna, brushing the darker color onto the still-wet surface much as a sculptor would use his thumb to push holes into the wet clay. Then while the surface is still moist, apply Ivory Black to the deepest, darkest parts of the form. Let the shape dry. It will look something like the example on this page.

You may prefer to use one color only for the three steps, commencing with a tint and then finishing with thick pigment.

The difference between this exercise and composed paintings such as those on the facing page is that the experiment isolates one shape on the paper as if it were sculpture in the round, whereas the composed paintings utilize *all* the sheet like a bas relief. We will investigate the distinction further in the lessons about method.

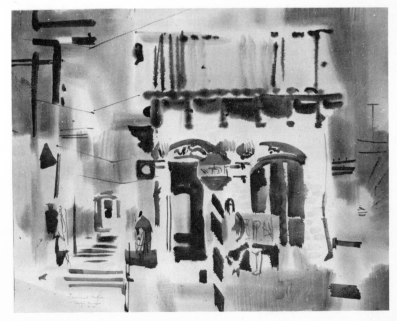

CLAREMONT STATION, 20″ x 24″

LALA LASLI, 21″ x 13″

It took about forty minutes for this sketch, commencing with a well-soaked sheet and concluding with drybrush for the chairback and hair.

Painted on location. The hot sun required completion of the wet-into-wet "entourage" in less than twenty minutes.

QUESTIONS WHEN STARTING TO PAINT

Which side of the sheet shall I use?

If you hold the sheet to the light you will notice a watermark. When this reads correctly (not in reverse) you are looking at the top (preferred) side. Some papers also have an embossed trademark. This, likewise, reads properly on the top side.

Can I use the back of the sheet?

Yes. The quality is as good but the dimples are reversed.

What medium do you use for blocking in the picture?

Soft pencil, charcoal, or a thin gray brush line. Millard Sheets N.A. often uses a fountain pen, letting the ink lines show in the finished work.

How much drawing should I do before painting?

The least possible. Painting *is* drawing — with a brush. Too much preliminary drawing relegates the painting operation to the kind of "filling in" associated with a child's coloring book. Never shade the drawing. Just measure out the shapes and spaces. Save the rest of the work for your brush.

How can a design be transferred to watercolor paper?

Use pencil carbon, not typewriter carbon. Pencil carbon is free of grease and may be erased just the same as a soft pencil line. Lacking this, dust the reverse of the sketch to be transferred with colored chalk, then wipe off the surplus and trace.

What do you do about layout lines when the picture is finished?

If these lines were laid on lightly enough they will seldom show. If they do show and seem objectionable, they may be erased gently with a soft eraser.

What do you think about copying others' work?

I think that this has an important place in analyzing methods and in exploring techniques. It has nothing to do with *creative* painting.

May I paint from photographs?

Photography is another medium of expression just as is oil painting, etching, or lithography. To translate what is realized in one medium into the terms of another seems an awkward and unnecessary task. I do use photographs as aids in my commercial assignments; I also use a sketch book, written notes, maps, books, etc. Each supplies information and refreshes my memory, but that is about the most that can be expected.

Is it all right to use a viewfinder?

Anything, yes, anything that will help your seeing and increase your feeling for the subject at hand is good. I squint and restrict the view by making a window with my hands. Others use colored glass to help in seeing values (the glass reduces the varieties of colors).

What you have to do is reduce the subject to patterns, and these patterns (shapes) are the basis of the painting language.

A good many professional painters use a mirror to give them a quick "new" look at the subject, or to check any errors in proportion in their painting. A reducing glass is another useful aid.

What kind of an easel do you recommend?

Any device is satisfactory that supports your board independently thus permitting you to move about. Tripods, benches, chair backs, folding card tables all have their proponents. I have a dozen different outfits depending on the circumstances. Never hold the board in your lap!

Is it true that a painting should take only an hour or two?

For a landscape painted on the scene — yes — because light and mood may shift. Otherwise I refuse to make any rules. I have spent as much as a hundred hours on a watercolor, and then again have had success in fifteen minutes. Subject, use, size, and so forth enter into this consideration.

Can I paint with sea water?

The experts do not advise it, but it is done.

What size are the originals of most of the watercolors I see reproduced in magazine illustration?

There is a lot of variety here. Twice the size is probably a good average.

I have admired the clean edge of an unmatted watercolor. How is this accomplished?

Tape the edge of the picture with masking tape before painting. Remove tape carefully after painting is dry.

Should I paint in sunlight or in shade?

Shade is a lot easier, doesn't blind you, and makes it possible to see more subtleties of value and color. George Post likes sunlight. He says it forces values, makes for a bolder painting.

May I wear dark glasses when painting?

Most glasses filter colors unevenly, so if you're out for color nuances the answer is "no." I use them because I am more interested in clean, well-measured values and a rested eye.

Should I mix each color in the pan first?

For washes, yes. For bounce and movement, however, do most of the mixing right on the sheet.

Some teachers suggest starting with the darkest and richest colors, then "closing up" the painting with the lighter. Why do you start with the light values?

(1) Either way has advantages in wash painting, but "my" way allows several chances for checking and re-composing as each deeper value is placed.

(2) In painting wet-into-wet, one must work from the large lighter values to the small, darker shapes to keep the whole sheet moist.

How do you speed up drying?

In addition to the obvious devices such as placing in the sun, the following are useful:

(1) Addition of alcohol to water. Wine, whisky, or brandy is often recommended — externally, that is. The nineteenth century painter Paul Sandby favored gin as a painting medium in place of water.

(2) Pan paints dry faster than tube paints as they have less glycerine.

(3) Some commercial artists use an electric hair drier.

(4) In foggy weather the English recommend the use of a spirit lamp or a couple of Sterno cans. Hold watercolor face down over the heat, taking care to avoid smoking the sheet.

I like wet-into-wet painting. Why aren't there more lessons on it?

Wet-into-wet is just wash painting with no pause for drying. You cannot succeed until you are the confident master of value and color mixing and, above all, have developed a clear plan of attack. Wash composition is the root of this. Once you have mastered it, wet-into-wet comes easily.

What's wrong with touching up my painting with opaque whites (such as Chinese White)?

Opaque color does not lie on the surface of the sheet, but appears to stand free in another dimension. That is why it is so easily detected. If you are aware of this and use the "foreign" material decoratively, it can be very successful. Otherwise, it is best to plan to lift or wipe out your whites.

Should an area be wet or dry before laying a wash?

I recommend learning on the dry sheet. Then you may want to try the wet method. Here are some tips:

Sponge the area lightly — about half the water squeezed out of the sponge — and then use a large brush and full strokes that overlap each other about half-way. Of course the sheet has to be dry for subsequent washes.

To avoid muddying or lifting with these later washes, Leonard Richmond recommends putting each wash on overstrength and then "washing down" with clear water to remove excess pigment. This may be repeated after each color is applied.

My washes have a hard "rind" or edge and are thin in the middle. Why?

Too much surplus water. Cultivate the habit of picking up such pools with the brush before they begin to set. Hard-finish papers aggravate this condition.

How can I get the sheet wet again for another go at wet-into-wet?

(1) If there is not too much impasto, the sheet may be gently dipped into a water bath again.

(2) If there is too much paint, apply water with an atomizer.

(3) If the sheet is not too thick, lay it face up on a piece of soaked blotting paper. Slight pressure will speed up the moistening process.

How can I lighten an area?

(1) Paint an even darker shape or texture within it. This is the direct method, and lightens the area by contrast.

(2) Carefully moisten with clear water and lift or blot.

(3) An eraser on the dry sheet will lighten a wash appreciably.

How can I deepen an area without muddying it?

(1) As in the question above, by contrast. Lift a light shape within the wash. The wash will appear darker by contrast.

(2) By glazing.

(3) Apply additional paint with sponge or drybrush to keep the color underneath "breathing."

My painting is overworked. What can I do about it?

(1) Try a new sheet. Phil Dike tells me he has done as many as twelve paintings of the same subject before getting the one that satisfied him for freshness and spontaneity!

(2) A stiff-bristled brush may be used with much clear water to lift bits or areas out. Then repaint.

(3) Dip the painting into a tray of clear water. While it is submerged, use a bristle brush or cellophane sponge to agitate the overworked areas, floating the muddy pigment off. Let the sheet dry and then try again.

(4) Glaze the whole sheet with Chinese White and then paint back into it, gouache style.

OTHER QUESTIONS

My washes have pinholes of air which leave white spots when dry. What can I do?

Droplets of oil are present. Sometimes this is from the hands or from the air. Flush the sheet well with clear water. Addition of alcohol or a moistening agent to the water is helpful. Just a few drops is all that is needed.

From the standpoints of texture and luminosity, sometimes this is a distinct advantage.

While painting wet-into-wet I get a frothy quality. Why?

The sizing in the sheet has worked to the surface because of excessive soaking or immersion in too warm a water. (Warm water is a speedy way to get the sheet saturated and is not harmful unless it is so hot as to create the above problem.)

My stretched paper popped loose. What do I do?

Cut it off and make a new one. There is no half-way about a stretch.

What causes sunbursts in my watercolor?

At the edge of the sheet: Surplus water gathering against the tape or paper edge and then flowing back onto the sheet as it dries. Learn to pick up this surplus with brush or sponge while painting.

Within the picture: Accidental drops of water into wash areas that have not completely set. (I once watched Millard Sheets turn such an accident into a bird in the sky).

I seem to get nothing but muddy color. Why?

"Mud" is largely a comparative term. It usually means that you have a long, uninterrupted passage of opaque color. I try to alternate opaque and transparent passages. However, here are some ways of avoiding the problem if it bothers you:

(1) Avoid excessive overpainting, i.e., second and third washes.

(2) Don't mix colors that are too far across the color wheel. For example, in making a green use your coldest (greenest) blue instead of a purple blue such as Ultramarine.

(3) Don't mix two opaque colors. Rather, mix a stain with an opaque. Example: Make a green of Yellow Ochre stained with Prussian Blue instead of Yellow Ochre and Cerulean Blue.

(4) Use plenty of clear water for color mixing and brush rinsing.

(5) Finally, if I have an objectionable muddy passage in the picture and do not wish to wash it off, I will paint an even muddier piece within it, thus opening it up by contrast.

Is watercolor ever used in conjunction with other media?

Yes, in many ways. Here are some:

(1) Watercolor plus the yolk of an egg makes egg tempera.

(2) With casein or Chinese White it makes gouache.

(3) Into wet plaster for frescos, it mixes more easily than the traditional dry color and lime water.

You stress three principal techniques. Are there others?

No. Special techniques come within these broad classes. An example is the so-called "stained drawing" of Claude, Rembrandt, Tiepolo, and Dürer. In essence it is wash painting.

My finished paintings are buckled and will not lie smoothly in the mat. What shall I do?

They have buckled because they have been cut off the board before all the parts are dry. Don't cut the stretch off too soon. If it is buckled, re-moisten the back of the watercolor and then press until dry between sheets of blotting paper or newspaper.

Is watercolor used to any extent in commercial work?

Over 80 per cent of all commercial art work is in the water-based media. If we include the inks (which, like watercolor, depend on white paper for their luminosity) it is nearer 100 per cent.

What proportion of the paintings in current exhibitions of watercolor are painted outside — that is, on location?

About one in fifty.

Why do so many critics rank John Marin as one of the great watercolorists?

I don't want to discuss esthetics in a book on technique, but even technically Marin is of singular note. Study his work from this point of view. Note the rich play of all the special devices of the watercolorist: Wash, wet-into-wet, brushline, drybrush, the wedging of plane against gradated plane and, finally, the glorious use of white paper.

What painters should I study?

Any and all of them. The more you see, the more you will be able to discriminate. Some favorites of mine (not necessarily in the order of importance) are:

All the Chinese and Japanese, including the Japanese printmakers; the landscapes of Claude (Lorraine) (1600-1682); the exquisite handling of W. Russell Flint of England; the brilliance of the German Max Pechstein; the line and wash of Tiepolo and Rembrandt; Daumier and Rowlandson.

There are many good contemporary Americans. Their works may be seen in magazines and painting exhibits from coast to coast.

AUXILIARY TECHNIQUES and INVENTIONS

Pure or transparent watercolor is universally appealing because of its candid informality — nothing is hidden, everything the artist does is revealed. But such ingenuous simplicity may create problems.

Problem number one is *thinness:* The washed out, untextural painting common to many students.

Problem number two is *lack of boldness:* The product of fear on the part of the painter. Because he cannot hide his mistakes, he may not dare to try the bold statement that his feelings dictate.

I call the following glossary "corrective-creative" techniques because they can both patch up mistakes and enrich your work.

For convenience, these devices are grouped by stages: *Before wetting* paper; while *wet;* and *after drying.* However, these are not exclusive and many lend themselves to more than one stage of the painting operation.

Assignment:

Study the following examples, and then make an abstract painting — no subject matter. Use at least six of the devices listed. Try for optical effects, contrasting thick and thin passages. Make the surface rich and texturally varied. Identify the different devices you use on the back of the picture or on a transparent overlay sheet.

Materials:

Assemble the additional materials and equipment required before commencing each lesson.

OLIVER LUNDY'S STORE, 21″ x 29″

The juicy directness of a swinging full sheet does not permit many paint-around whites, so we employ rubber cement, paraffin resist, sponge lift—all discussed in this lesson.

BEFORE PAPER IS WET

RESISTS

(1) Masking tape may be cut or torn to block out small, uncomplicated shapes. Press it down firmly to keep moisture from carrying pigment underneath.

(2) Rubber Cement or commercial resists such as Maskoid, Misket. Small white objects in large wash areas — for example, sea gulls in the sky — are hard to work around. Coat these subjects with rubber cement. Wash will go over the top and then, when all is dry, the cement may be rolled or peeled off.

Interesting surfaces may be developed with rubber cement. For example, run a wash of thin stain color and then coat the area with rubber cement. Lightly run your hand over the cement surface when dry, letting the grain of the paper break through. Run a second watercolor glaze color. It will hang on the cement edges, filling the exposed parts, producing a fish-scale pattern.

(3) Crayon or Paraffin. Wax resists washes, giving a stained glass or batik effect. May also be used between washes.

MEDIA FOR LINE AND LAYOUT

(4) Pencil or Charcoal. Most painters sketch lightly and do not try to erase the faint lines. If too soft a lead is used, the resultant greasiness makes painting difficult.

(5) Felt-tipped Pen. Most pens of this type have waterproof ink — but some do not — therefore the water-soluble brands are less useful. Caution: Most inks for felt pens will fade with time.

(6) India Ink. Waterproof and permanent, a favorite of artists for centuries. Examples: The line and wash of Rembrandt and Tiepolo.

(7) Indelible Pencil. Used under watercolor as drawing, it will bleed and fuse into the wash. To model your pencil drawing, wet just one side of the line with a brush and clear water.

(8) Ball Pens. Often used in place of the pencil or to correct the pencil drawing. The line remains, and sometimes bleeds, which may not be desirable.

(9) Specialty Pens. Almost daily, new pens and inks are placed on the market. The Esterbrook pen (illustrated) is an exotic "bleeder," which yields strange purples and greens when moistened.

MODIFYING THE TEXTURE OF THE SHEET

(10) Wire Brush. Vigorous strokes in one direction will produce a wheat-field-like texture.

(11) Sandpaper. Not too coarse a grade, unless you wish scratches. The surface thus abraded tends to accept more paint, making a darker texture.

(12) Scratching. Knife or razor blade scraping makes abrasions into which pigment settles to achieve a rough texture.

OTHER

Burnishing Paper. Smoothing rough paper with metal or agate burnisher before painting gives the wash a different, smoother effect. May be used after the wash to correct muddy passages.

1 2 3 4 5 6

12 11 10 9 8 7

WHILE PAPER IS WET

ADDITIVES

(1) India Ink. Caterpillar-like, furry edges are the result of the incompatibility of water and the shellac in the ink.

(2) Opaque White. Chinese White or poster paint will bloom almost like a neon sign if loaded heavily onto a moist paper surface.

(3) Chalks, Bronzing Powder, Powdered Pastel. Scrape, dust, or draw these dry materials into a moist, pigmented wash.

(4) Spatter. Often used when the sheet is dry; it is softer and ties in gracefully if applied to a wet surface.

(5) Monoprinting. Paint a pattern on a dry sheet of paper using heavy, wet color. Quickly press it face down on a moist sheet of watercolor paper to make a soft, reverse image. Or coat a pebbled cardboard and print with it. Example: Corrugated cardboard makes a picket-fence pattern. Or, coat the edge of a scrap of matboard and print with it to make jack-straw patterns.

(6) Finger Printing. Drumming on the moist work with the clean pads of the finger-tips creates a dappled texture. Or a finger may be rubbed in paint and printed.

LIFTS

(7) Sponge. A moist natural sponge will lift almost any color clean while the sheet is still moist.

(8) Kleenex or toilet tissue. A more wrinkled pattern of lights is raised by blotting with crumpled tissue.

(9) Blotter. One of the most versatile auxiliary devices for the watercolorist. Shapes of sun, moon, rooftops, etc., may be cut out in advance of painting and pressed into the moist wash. You may leave these pieces in place, painting wet-into-wet over them — like a stencil, as in the example — to increase contrast.

(10) Squeegees of cardboard, rubber, or metal. Trim small pieces of matboard, or use a rubber kitchen-garbage-scraper, or a knife blade to strip sections of wash off the sheet.

(11) Brush handle. With a pen knife, shave the end of your brush handle to a chisel shape to make a useful squeegee. (Some plastic handles are already shaped this way.) A fingernail will work as a substitute. The strokes will suggest surfaces within a rock mass, twigs and limbs in a tree mass.

(12) Salt. Sprinkled over a rich wet wash, salt grains will draw water — and, of course, the color — to them. Dust off when completely dry. Surface looks like a caracul coat.

| 1 | 2 | 3 | 4 | 5 | 6 |

| 7 | 8 | 9 | 10 | 11 | 12 |

AFTER WASH HAS DRIED

LIFTS

(1) Sponge and Stencil. Stencil paper or photographer's film may be cut to make a pattern. Stipple color on with sponge or brush; use a moist, clean sponge to lift color up.

(2) Paint Rag. A substitute for the sponge. It does not lift the color quite so well.

(3) Brush. Any brush with clean water will do, but for clear lights use an oil painter's bristle brush, blotting the moistened area repeatedly.

(4) Eraser. For minor corrections use a soft eraser, but for a cleaner white try a hard "typewriter" eraser.

(5) Scraping and Cutting. Sections may be scratched clean, as in some of the works of Winslow Homer, with a penknife, or removed with scissors and new bits pasted over or under.

(6) Sandpaper. Particularly effective on rough paper. Additional washes may then be run, which will soak into abraded areas.

ADDITIVES

(7) Spatter. Load an old tooth brush or other stiff-bristled brush with paint. Then scrape the bristles with a penknife or drag the brush over a piece of window screen.

(8) Stipple. Like spatter, but created by repeated stampings with a bristle brush or, preferably, a short, flat stencil brush held vertically.

(9) Airbrush or fixative blower. Spray the watercolor on, using templates or shields where edges are to be hard.

(10) Collage. Paper may be used either to provide a different surface or to cover up a disaster. The example illustrates three effects: (a) Semi-transparent, by use of tissue or Japanese rice paper; (b) semi-opaque, by the use of all-rag, thin writing paper; (c) opaque, by the use of a second piece of watercolor paper. Be sure the papers are all-linen rag content so they will not yellow with time — and use a permanent glue (not rubber cement). One may paint additional washes over these new laminations.

(11) Opaque White. Chinese White will seem to jump off the sheet, so use it with care.

(12) Bleaches. Laundry bleaches may be applied with a brush. Allow to percolate for a few minutes before flushing the area completely with clean water.

OTHER

Wash Off. Paint heavily on a hard paper surface, then lightly wash off part of the paint in water tray or under faucet to give a mottled look.

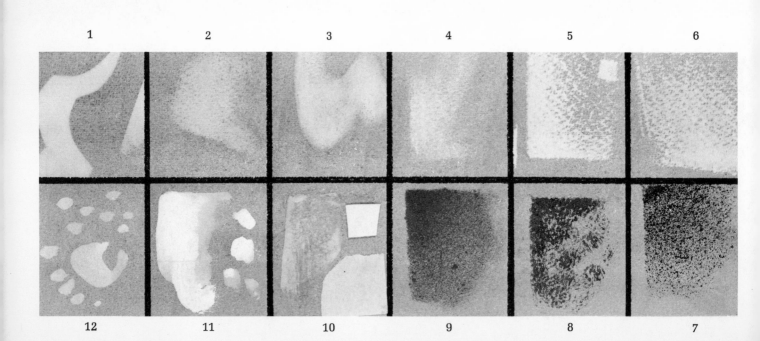

1 2 3 4 5 6

12 11 10 9 8 7

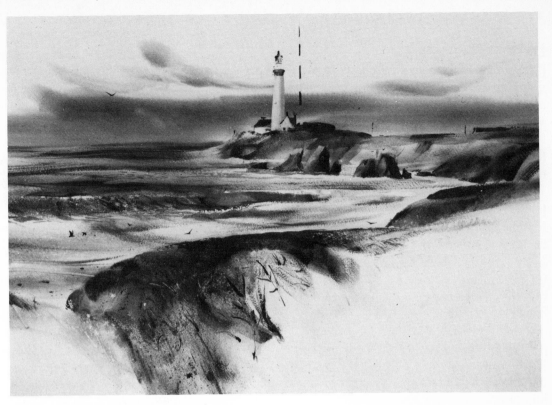

PIGEON POINT LIGHT, 21″ x 29″

The white tower of the lighthouse is accomplished by lifting the colors of the sky with a damp sponge guided by two pieces of paper which act as a stencil.

PAPER WHITES vs. PIGMENT WHITES

The gleaming gingerbread ornamentation invited a bold interplay of transparent paper with opaque white pigment to give the surface a pulsating or jumping sensation. The Chinese white, not a necessity, is used solely for creative reasons.

SAN FRANCISCO TOTEM, 22″ x 12½″

VARIATIONS AND INVENTIONS

WITH PAPER

Folds. Creasing either the dry or moist sheet will cause linear abrasions in which the color settles more heavily. (Example: Along the left side of illustration, page 89.) Do not crease too firmly or the sheet will tear when stretched.

Unusual Paper. Cloth, metal leaf, blotting paper, hard-finished papers, and coated stocks give variations to the paint quality.

Colored Sheets. Toned or colored surfaces are frequently selected as a support for collage, opaque paint, or crayons and chalk.

ADDITIVES

To speed drying: Alcohol. A few drops of vodka in the paint water is my favorite.

To retard drying. A few drops of glycerine in the paint water.

To eliminate pinholes. A few drops of ox gall, a commercial wetting agent, or any detergent soap that contains a wetting material. Too much will cause frothing and a tendency of colors to sink unevenly into the sheet.

To reduce running. Add a few drops of gum or honey. Winsor and Newton provide *Water Color Megilp*, a solution of Gum *Tragacanth*, for this purpose.

To enrich color and improve mixing. Some painters use sodium silicate (water glass) or potassium silicate as in the medium of stereochromy, but these may become powdery with age. Winsor and Newton provide *Glass Mediums* — Gum Senegal plus Acetic Acid — for this purpose. Use only a few drops in a half pint of water.

To thicken the pigment coat. Add finely ground silica to the mix; *Aquapasto* by Winsor and Newton is similar. Do not use too extensively or the bond may be weakened.

To make the painting water-insoluble. Combine a small amount of white glue (Polyvinyl Acetate Emulsion) with each mix. Or apply it to the completed watercolor by brush or air-gun spray. You may substitute a ready-mixed Acrylic-Vinyl Copolymer for the above. This is available in pressurized spray cans from most art suppliers.

To provide an impasto quality for modeling. Coat the sheet with a paste-like base before using transparent colors. Some of the materials used for this purpose are: (a) corn starch; (b) wallpaper paste; (c) commercial preparations such as *Pelikanol*; (d) Chinese White.

To make gouache (Opaque Watercolor). Add a tube or jar of Chinese White to your palette and mix with each color.

1. Crumpled paper

2. Wash off

3. Suction print

OTHER EXPERIMENTAL TECHNIQUES

Crumpled paper. Drop pigments onto a moist, light-weight sheet and crumple the surface by balling and crushing while it is wet. When smoothed out to dry, the result is leather-like texture. This effect may be controlled by gathering and "wringing" sections, instead of the whole sheet.

Wash-off. A hose, an ear syringe, or a brush with clear water may be utilized to flush off passages of pigment, usually while the area is still moist. Acetone or denatured alcohol also may be used for this purpose, with exotic effect.

Suction printing. Moisten two sheets of smooth paper. Apply pigment and then press the two sheets firmly together. When pulled apart, all sorts of underwater-like textures appear, depending on how much paint and how wet the surfaces are when contacted. More suction may be created by the use of glue, glycerine, or other viscose additives.

Sponge painting. For the massive, textural feeling of a fresco painting try building up the painting with a sponge in a drybrush approach. Stencil shapes may be introduced as illustrated.

Monoprinting. Textures may be borrowed from everywhere and everything. The fish print (illustrated) was made by coating a freshly caught fish with black paint, and then wrapping the surface in absorbent Japanese rice paper.

Stones, leaves, driftwood, twigs, or coils of string may be coated to provide a pattern. Some papers print better when pre-moistened.

The example below at right is the result of rotating the heel of a rubber-soled shoe on the wet paper.

4. Sponge and stencil

5. Monoprint, fish

6. Monoprint, rubber heel

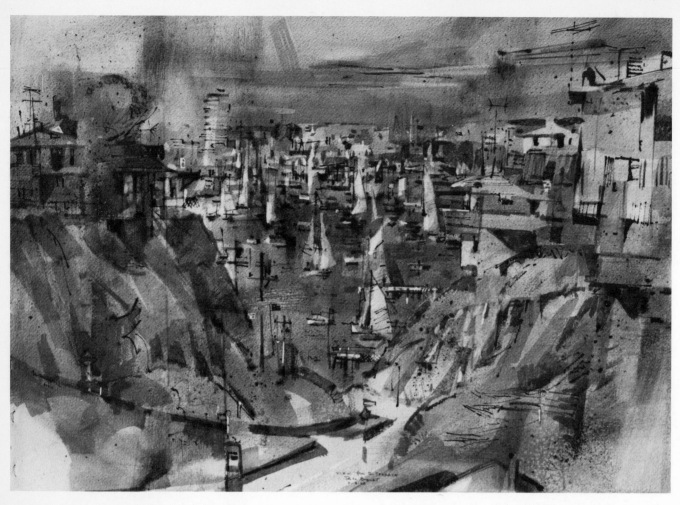

VIEW FROM THE TERRACE, 21½″ x 29½″
See section shown in color on facing page.

Collection E. Gene Crain

EXAMPLES OF THE USES OF AUXILIARY TECHNIQUES

I employ the auxiliary techniques to enrich my larger studio paintings, of which the four on these and following pages are typical, and to provide variations of interpretation and mood.

"VIEW FROM THE TERRACE" above and facing is a full 22″ x 30″ sheet inspired by a complex pattern of boats and buildings. To convey a sense of textural variety, I employed the following special technique:

(1) Horizontal striations (lower right and left center) are produced by wire brushing.

(2) Crayon has been applied before paint in small areas. Example: Ochre in roadway, touches of light green in center areas.

(3) Spatter into wet is prominent in the foreground.

(4) There is a whole glossary of whites: Some boat shapes are produced by brush-handle squeegee, others by paint-around, collage, and opaque white paint.

(5) Variety in the darks is achieved by a mixture of paint, India Ink, and gray felt pen (the near telephone pole).

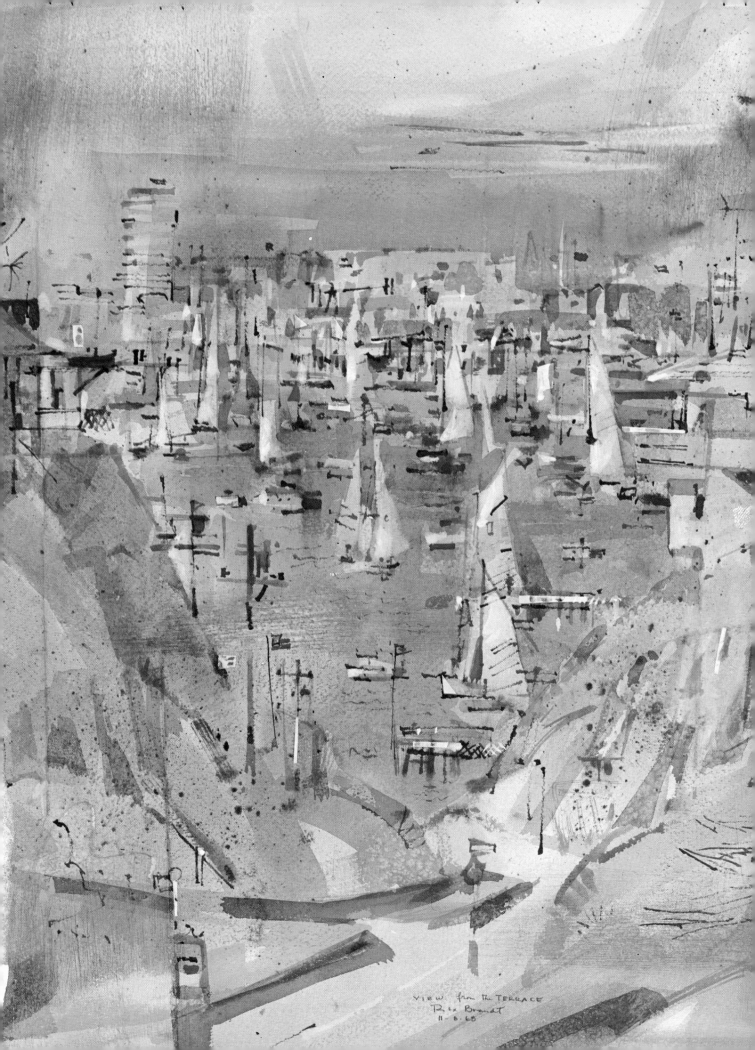

VIEW from the TERRACE
Rex Brandt
11-6-68

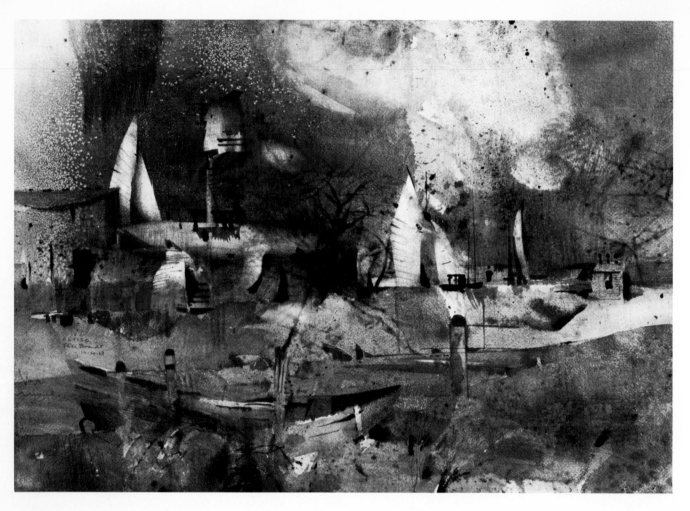

ALVISO, 18½″ x 27½″ Collection E. Gene Crain The Bronze Medal, American Watercolor Society, 1970

"ALVISO" (above)

Spider web patterns of trees and in the sky are the result of selective crushing and folding at the time this full sheet was stretched.

A wire brush (upper left) and then salt (the dark sky area) provided textural variety. I walked on the wet sheet with rubber-soled shoes to leave the imprints around the foreground derelict boat.

Whites were produced by use of the sponge and stencils — after the washes were dry.

"PAVILION AND BAY" (opposite)

Contrast the final watercolor with the preceding pencil study opposite, top, and you will agree that the negative spaces of sky and roadway are more exciting in the painting. They were animated by the wire brush, salt, and crayon additives. The darks have been intensified by the use of India ink finger-painted into the still-wet watercolor.

Pencil study for studio watercolor.

PAVILION

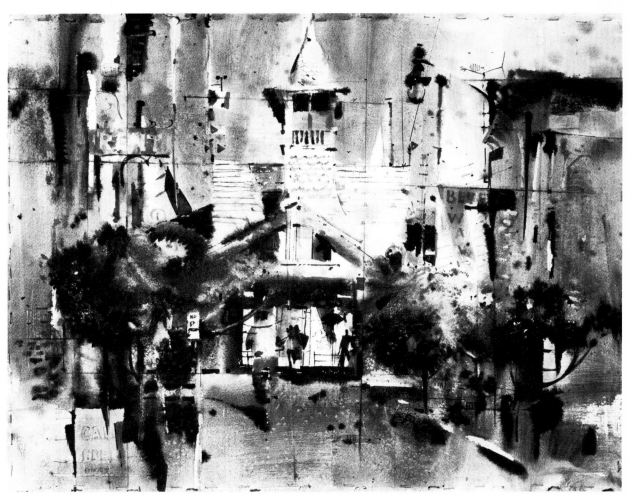

PAVILION AND BAY, 21½″ x 29½″

Collection E. Gene Crain

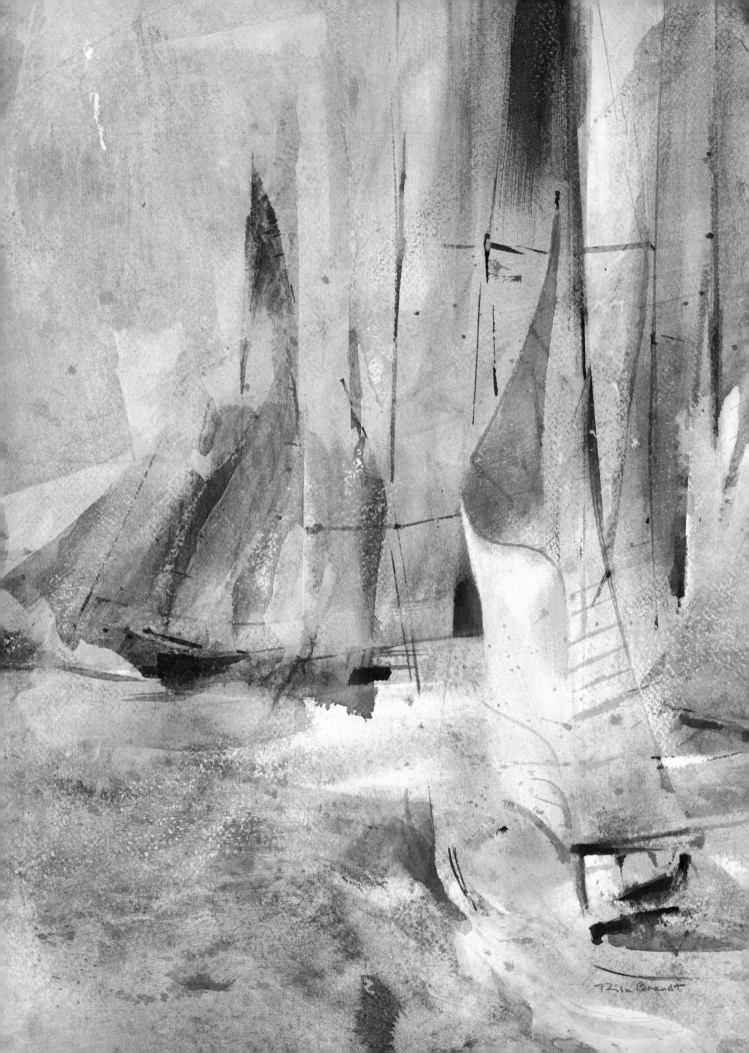

1

2

3

4

"TACKING IN A HEAD SEA"

Not all watercolors are completed in thirty minutes. For example, this painting was on the board for two months and underwent a major correction before it was considered complete. Some of the techniques used in its development are illustrated at left.

(1) The composition was pencilled in, and then inked onto a 25″ x 40″ ("Double Elephant") sheet of 140# Arches.

(2) The soaked sheet was first painted wet-into-wet, then stapled to a board while still wet. Some areas received a salt texture at this time.

(3) Washes were used to define the shapes of sails.

(4) After several days of intermittent contemplation, I decided the work was too slick and would have to be destroyed. However, before giving up I tried wetting the surface with a garden hose, jetting off some of the slick edges. This was helped along by the use of strong bleach, dropped onto the wet surface and allowed to flow and percolate for several minutes before it, too, was hosed off.

Certain edges still seemed too hard, for example, the boats at the left, so pieces of tissue paper collage were glued in place.

(5) Several days later, when all was dry, the surface received final touches of wash and line. (Color plate opposite.)

Opposite:

TACKING IN A HEAD SEA
Collection Mr. & Mrs. John Gilbert

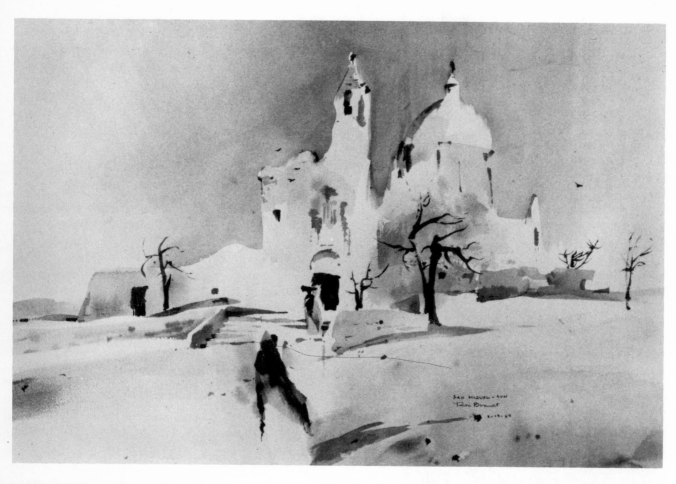

SAN MIGUEL — SUN, 13½″ x 20″

White paper is to the watercolorist what white marble is to the stone carver. Nothing is more tangible or more eloquent. Applying paint to paper is analogous to stone carving: it reduces the whole to intensify the remainder.

This thirty-minute watercolor is an example. The key form of the church is white paper, untouched for the most part. Paint has negated the large areas of sky and foreground.

94

Ten lessons in METHOD:

THE WAYS OF TRANSPARENT WATERCOLOR

Once we are in command of our medium, we are ready to paint. The technician becomes the tactician, the craftsman is now composer. The question "How?" is supplanted by "Why?" and "What?" Our task is to single out that quality in the experience around which we can build a painting. This must be determined before we paint, for white paper, once coated, is not easily recaptured.

I still occasionally fall into the trap of the un-planned watercolor; enthusiastically I pencil-in my drawing, moisten the palette, pick up a brush — and *then* discover that I have no clear plan or goal in mind. What color shall dominate? Where shall the all-important white be left? Where will the climac-tic, harder-edged darks settle?

When this happens, I have learned to put the brush down and think, possibly making a marginal note or two before proceeding. I try to locate the key of my design, the "first form" or "center of interest." I try to leave this as white paper and then concentrate on the so-called negative shapes.

One must learn to **see the positive, paint the nega-tive.** Approach the paper as a sculptor attacks a square block of white marble, chipping away all that is unessential. The remaining marble is the sculpture; the white paper is the watercolor. Think positively — holding the image in the mind — while working "negatively," painting "out" all that is unimportant.

The following experiments will help you identify an objective, and then maximize it by "carving into" the white paper without destroying its flat, rectangu-lar integrity.

If you are one of the many who has said, "I admire watercolor, but it is too difficult a medium for me!" I suggest that you stay with value painting until you have mastered it. Add color slowly, relat-ing each additional pigment to the dark/light plan.

1 + 2

1 + 2 + 3

1 + 2 + 3 + 4

MAKING WHITE [PAPER] WORK

These diagrams compare the attention-demanding nature of white paper in contrast to dark paint. The phenomenon is the basis for the lessons in method.

The two circles at left are of equal size. Which looks larger? Which comes forward and asks that you read it? The white circle does because its light stimulates (irradiates) the nerve endings of the eye. At the same time the dark — the absence of sensation — appears to shrink.

Because light appears to expand and dark to shrink, the darks secure the whites. By nature they are forced to assume a supporting or background role in composition. The stage manager makes his principal dancer stand out by putting the spotlight on her and reducing the light on the rest of the chorus. The watercolorist stages his painting in the same way, by assigning white paper to his key shapes.

This art of chiaroscuro is by no means limited to the painter of watercolors — but it is vital to him, for the loss of reflectant white is the death of transparent color.

HOW THE PAINTER COMMANDS THE EYE

Here are four variations on one composition. In each variation the attention is drawn first to the point of maximum contrast of value. For example, the lighted sky of the first picture invites the eye to see the distance, while the lighted sand areas of the lower version keep the attention focused on the foreground.

Control of the sequence in which the eye reads the painting is as important as the arrangement of the shapes themselves. Because of the demands of the extremes of dark and light, their relationship is more critical than that of the grays. Happily, the moving sun supplies us each day with a continuously changing series of value relationships from which to choose.

These value relationships are identified and illustrated on pages 124-125.

Sky

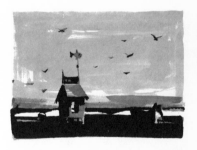

Water

Building

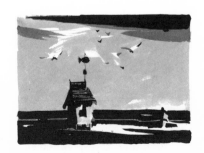

Sand

11 WASH COMPOSITION IN FOUR VALUES

A STILL LIFE

Light in watercolor is white paper. Because watercolor is transparent, even when thickly painted, it is wise to use white as a color so that pigments may appear to have weight by contrast.

Unlike with any other medium, this means planning the white before you touch the paper. This planning often confuses the expert in another medium, accustomed as he is to placing such accents at the last.

Because light paint won't cover dark paint in watercolor, it is generally advisable to work from light to dark. By the same token, it is possible to work from very broad areas to smaller areas since the progressively darker washes will overlay and obscure the lighter ones.

The extremes of dark and light are the accents. The grays are the "amalgam" which holds the picture together. They are also that section of the value scale wherein color does not need to be tinted or shaded. Accordingly, we give more space to them on the value scale.

Assignment:

Place two or three simple geometric shapes in a tight overlapping arrangement as in the shadow box illustrated. Lightly pencil the composition onto a small sheet of paper and then, using the eye as a judge, assign each area a value number from one (white) to four (black or very dark) — whichever number corresponds most nearly to what you see. Also on this sheet allow space to prepare a value scale.

The first wash will be light gray. Cover **all** areas except no. 1 on both the sketch and the scale.

After this is dry, run a second wash of dark gray, covering all areas except nos. 1 and 2. Finally, paint areas marked no. 4 a rich black. While you are doing these, do the same for the value scale so that you will have it for a reference. See that the steps from white to black are even. Try for whites on the positive objects, and black against white in center-of-interest areas.

Materials:

Watercolor stretch, one brush, black or any one color.

Value scale

A typical subject

Values suggested by local color or by exigencies of the design.

Values indicated by the direction of light.

12 COMPOSITIONAL STUDIES IN MONOCHROME WASH

Eclecticism is the practice of selecting what seems useful from others and utilizing it for our own purposes. As a means of acquiring techniques and methods rapidly, it is hard to beat; however, as unthinking imitation it is pedantic. With this caution in mind I advocate the study of other artists' ways and, indeed, I am suspicious of the student or teacher who professes neither knowledge nor concern about the ways of the masters of his field.

This **Assignment** has two parts: First, compiling a scrap book or portfolio of examples, collected by the student for their particular interest to him; secondly, analyses of these works as shapes and values. Although a four-value analysis can be made of almost any work of art, and in most two-dimensional media, it is obvious that it will be complicated should the subject be either predominantly linear or based on colors of equal value — as exemplified by some Impressionist art. Therefore, for this study choose examples that have strong pattern. I have selected examples from this book, but you may enjoy looking elsewhere.

Proceed as in the previous lesson by coating the entire area, except the whites, with the first light gray wash and so on to the final black accents. Try to simplify the study by eliminating all but the most important shapes and values.

Materials:

Same as previous experiment.

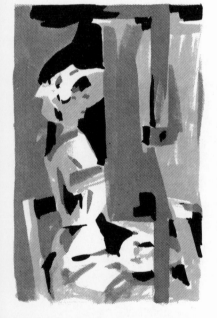

From example on page 123.

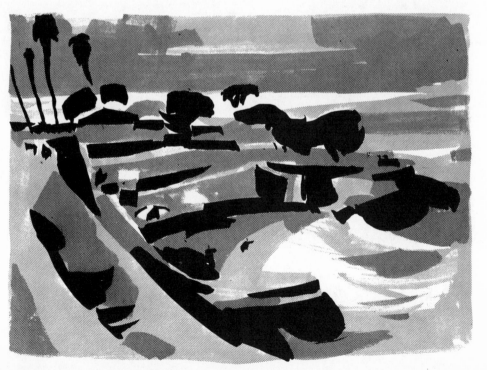

From example on pages 126, 127.

A step-by-step analysis based on the painting MAP OF ITALY, page 109. To discriminate between minor details and major shapes, try standing back and squinting at the work.

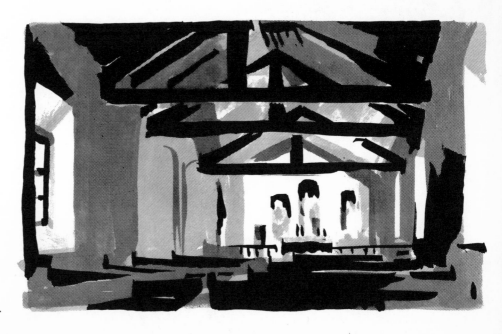

From example on pages 134, 135.

13

COMPOSITION FROM NATURE IN FLAT VALUES

Outdoor subjects are particularly confusing because objects move and the light is prone to change. To paint such material the artist must make a conscious effort to single out the significant and then establish it dominantly in his composition. To do this he must consider proportion, scale, position, and, above all, contrast. This lesson explores the latter.

Assignment:
Choose four of your paintings or sketches and lightly pencil replicas onto a watercolor stretch divided into four parts. Number the areas, and paint in grays and blacks as in the previous two lessons. Or you may prefer to try different value plans for the same subject, as illustrated.

Remember that white should be reserved for very important things, and that you can make this white even more brilliant by putting extreme dark against it.

Materials:
Same as last lesson.

Photograph of the subject at Tomales Bay, California.

Emphasis on the sky.

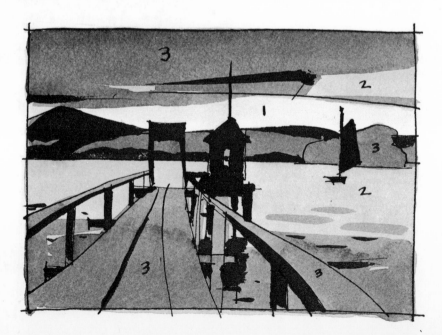

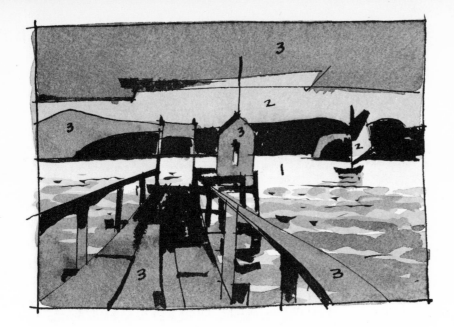

Water surface is dramatized.

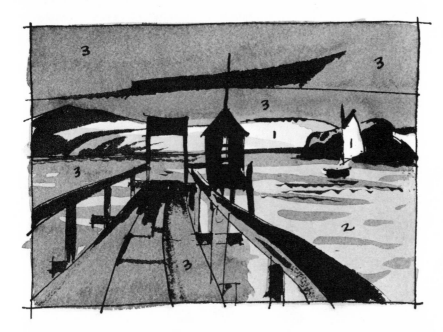

The eye is drawn first to the distant boats and hills.

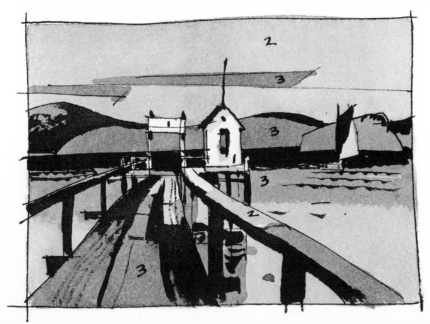

The shapes of the dock structures are developed as the "first form."

COUNTERCHANGE

To alternate, to reciprocate, to checker, to cause to change places or shift — these are definitions of *counterchange*. A checkerboard-like alternation of dark/light value, warmer/cooler color is the pattern of painting. Clues to these alternations exist in nature. For example, a white sail may seem dark against the sunlight, sunlit dark trousers may seem light against a shaded house, and so on. Learn to look for this phenomenon — it can be observed even in photographs — and use it to animate your composition.

NOT THIS →

BUT

THIS ↓

PASSAGE

If counterchange provides a rhythmic beat to the painting, passage may be said to provide its circulation. Losing and finding the edge of shapes, running areas of light together, seeing shade and shadow as one figure — these form a visual flux.

Avoid painting things. Paint conditions, configurations, *passages*, and then your watercolors will be simpler and stronger. Learn the power of understatement — the poetry of the unsaid. Paint verbs, not nouns, For example, instead of saying, "I am going to paint two boats on the beach," try saying, "I am going to paint the pattern of light and shade that *flows* across the beach."

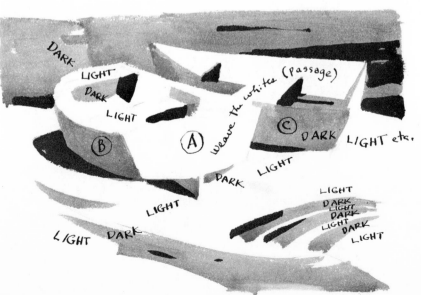

DON'T
PAINT
THINGS!
— Paint
Relationships!

14

EXERCISES IN VALUE PLANNING FOR A BOLD APPROACH

In spite of our fondness for bold whites, clear value steps, and simple pictorial schemes, there is a tendency to *niggle* in a painting. An antidote is to lay out the composition in cut paper or in some other medium that requires simplicity and geometric clarity. Here are some techniques that provide this discipline:

(1) **Paper Collage.** Select a sheet of middle-gray construction paper. Cut pieces of white and black paper to develop the pattern, arranging them with care before finally pasting them in place.

(2) **Linoleum Block.** (See illustration.) Carve out the whites only. Print the block with a light-gray ink. Now remove the areas that are to remain light gray. Print the remaining parts of the block dark gray. Do the same for the final black accents.

(3) **Silk Screen.** You will need a simple screen kit, a resist which may be painted on the screen, and black and white inks (to mix for the grays). Proceed as with the block print, blocking out one more value after each printing.

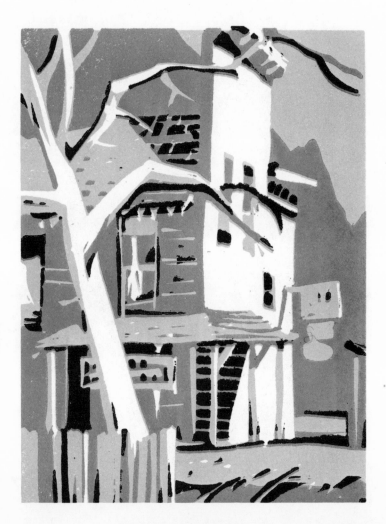

(4) **Broad-nibbed Felt Pens.** Select a light gray, a dark gray and a black felt pen. Draw on heavy white paper, placing progressively darker values over the lighter ones. If you have used pencil layout lines, they may be erased when you are through.

(5) **Duo-Shade Drawing Paper.** Treated paper coated with various gray, dotted patterns that can be developed by the application of special chemicals (provided with the paper) may be purchased. Use India Ink for the blacks.

Assignment:
Select four or more of your watercolor compositions. Try them as designs in one of these techniques. Keep the studies small and simple, about four inches square, or less.

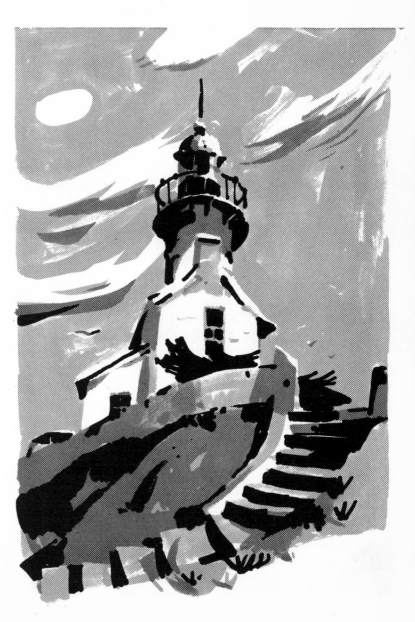

Made from the example on page 36, using the Duo-Shade paper. A brush was used to coat the entire sketch except the whites with the chemical labeled ''light gray.'' When this was dry, a second darker gray chemical was applied and blotted. Finally, the India Ink blacks were applied with a small brush.

COMPOSITION IN FOUR VALUES: A DEMONSTRATION

Fresh white laundry set against dark doorways inspired the watercolor shown on the facing page. Here are the steps:

(1) Two sketchbook pages: the original drawing, and a color snapshot pasted into the book later. (Below)

(2) Pencilled layout on a stretched full sheet, 140# Arches Rough. The whites are anticipated by a piece of masking tape (lower right at window sill) and some blotting-paper friskets, which are removed when wetting the sheet and then relocated once the sheet is moistened. (Opposite)

(3) Stage II. The warm, light gray "amalgam" has been completed with touches of spatter, stipple, and brush-handle scrape and allowed to dry. Then stencils and masking tape are removed. (Opposite)

(4) Dark gray washes, a mixture of Ultramarine Blue and Alizarin Crimson, are painted next to indicate shade and shadow. (Not illustrated)

(5) Darkest dark against lightest light, the doorways against the laundry, is painted last. These darks are minglings of Viridian Green and Alizarin Crimson. A few touches of calligraphy, for example the balcony hand rails, complete the painting. (Opposite)

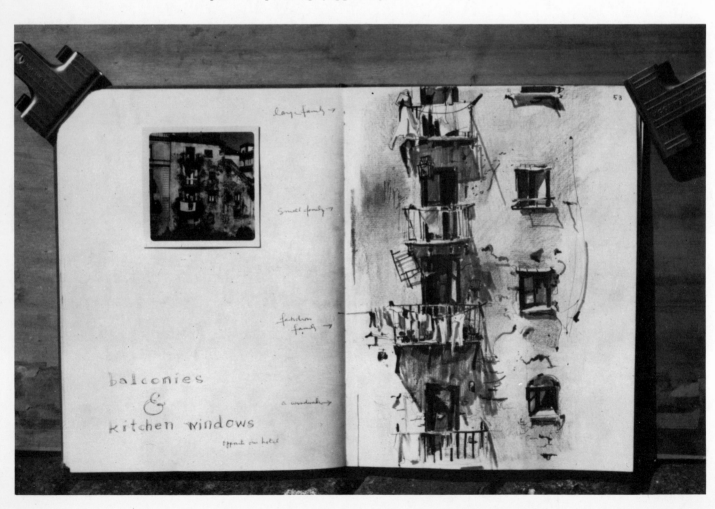

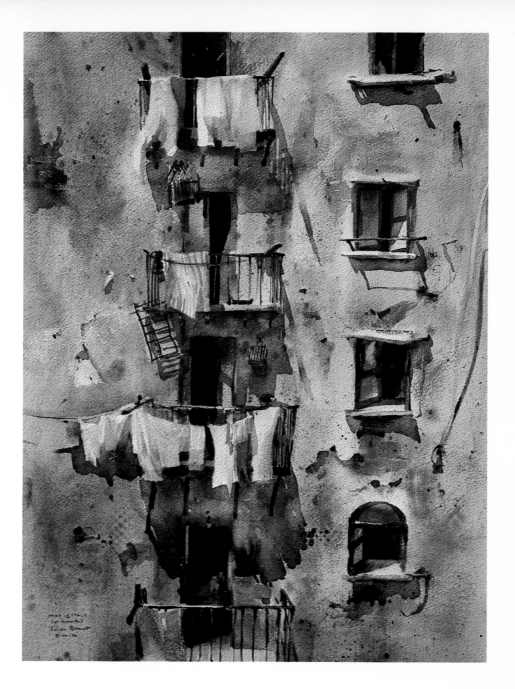

5. MAP OF ITALY, 28½″
x21″ Acquired by the
Council of the National
Academy of Design, 1970

2.

3.

15

GRAY: THE AMALGAM

Although the eye searches the accents of light, it is the function of the middle values to hold the painting together. The gray is the *amalgam* which gives cohesiveness and unity to the liquid design. I have called value the "chassis" of watercolor, for it is indeed the visual framework on which color and texture are carried; by analogy, the grays hold the framework together.

This demonstration by Robert E. Wood shows how quickly an experienced professional will establish a large, amalgamating gray in his first wash. The whites are created by painting around some, lifting others out with a sponge, as in the area by the porch, and now all is ready to hang the darks, colors, and brush textures to this framework.

The subject at Tacoma.

First wash

Second wash

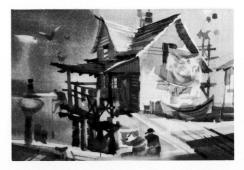

Calligraphy added.

Assignment:
Two or more quick, quarter-sheet studies based on any subject that interests you.

Procedure: Lay out the composition with a pencil, then coat the entire sheet with a middle-value gray. While this is still moist, lift the whites with a nearly dry sponge or paint rag. Allow to dry, then paint the locking dark gray, and finally the black accents as in the example on this page.

Caution: Don't use a stain color for the gray if you would have success with the whites. For example, a gray made by mixing Ultramarine Blue and Burnt Sienna will lift, whereas a gray of Payne's Gray will not.

The subject in the alley.

Second wash

First wash with whites lifted.

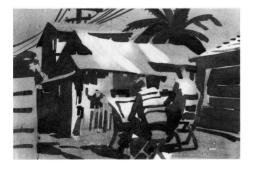

Calligraphy added.

111

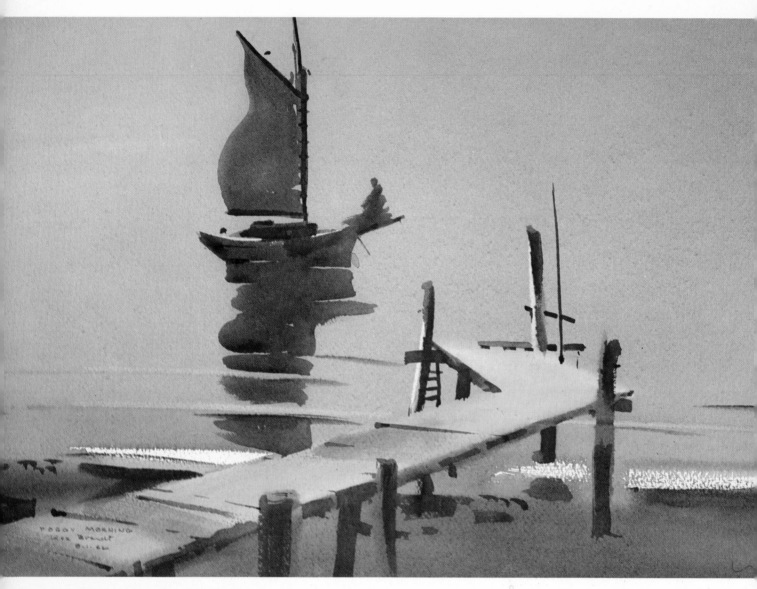

FOGGY MORNING, 12½"x18½"

Four-value study

"FOGGY MORNING"

The low-keyed limited palette (page 120) has been augmented with Cobalt Blue to create a silvery gray color scheme in this example, but emphasis remains on value.

Two techniques for establishing the lights are illustrated: (1) Paint-around, the breaking wave and (2) Sponge lift, the end of the pier. The light gray first wash is a mixture of all four pigments — Yellow Ochre, Ivory Black, Burnt Sienna, and Cobalt Blue.

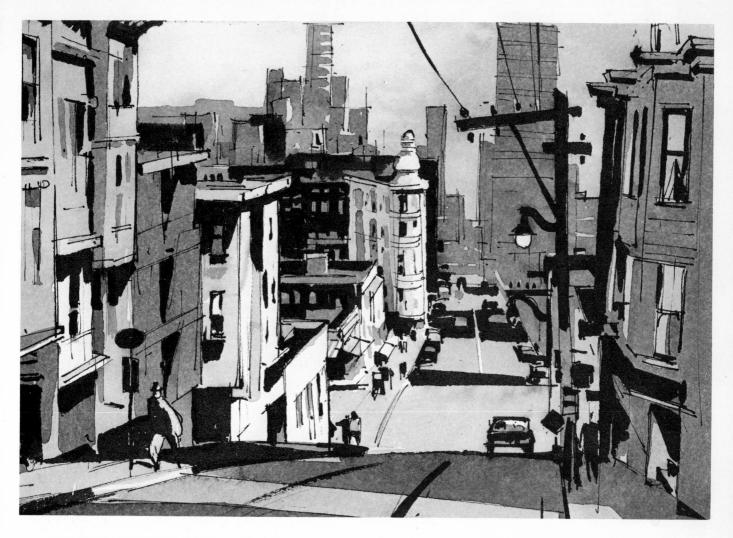

STREET IN SAN FRANCISCO, 6½" x 9" Monochrome

Photograph of the subject.

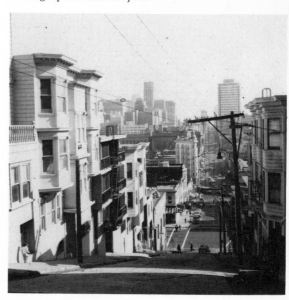

"STREET IN SAN FRANCISCO"

Note how the light gray wash reduces the contrast everywhere except at the U-shaped pattern of middle-distance buildings, the focal point of the design. The example is painted in three washes of Lamp Black, but would look very handsome in a restrained palette such as that used for FOGGY MORNING on the facing page.

16 MAKE POSITIVE USE OF "NEGATIVE" SPACE

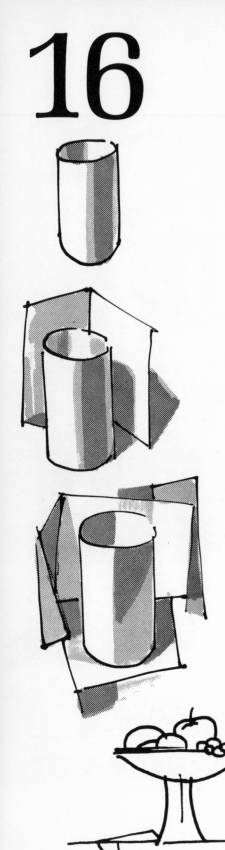

The axiom "Animate the negative space, for positive shapes take care of themselves" must have been first spoken by a watercolorist upon discovering that all paint on all paper did not a watercolor make!

Hopefully you are now at this stage, in which case I can hear your next question, "But what shall I DO with the empty space?"

A superficial answer is to enrich the background shapes with color, texture, and decorative inventions such as sea gulls, sign boards, and scaffolding. But, at heart, what we seek is a genuine reciprocity — a give-and-take between object and non-object — which will make each inch of the paper important. The clues lie in value and color relationships seen by the eye but not always perceived by the mind. As an example, place a white cylinder before a white background and carefully study the relationships. You will discover that the background appears darker against the light side, lighter against the dark side; and also that color seems warmer (yellower) in light and cooler (bluer) in shade. These are the products of the simultaneous contrast of object and background, and provide a basis for determination of value and color relationships within the entire painting area.

The assignment will help you to make your negative (background) shapes a meaningful part of the composition.

Assignment:

Select a simple solid as subject and do an undetailed line drawing not over six inches in any dimension. Make three separate tracings of this drawing on a stretched watercolor paper. Then try the following exercises, first in monochrome, repeating them later with color if you are ambitious.

(1) Use the wet-into-wet technique to establish a soft counterchange of values (*sfumato*), as illustrated opposite. When dry, sponge out any lost whites and then paint the positive shape of the subject as a reciprocate.

(2) With pencil or ink divide the background vertically and horizontally to tastefully relate the object to the frame. Paint the resulting checkerboard in alternate darks and lights, using the principles of counterchange and passage.

(3) Instead of the abstract geometric division (above), try borrowing shapes from the environs of your subject — such as a doorway, window, furnishings, or plant materials. Relocate them if necessary, to bring them into juxtaposition with your subject.

An exotic twist is the surrealistic introduction of background shapes from another milieu. For example, place a barn door behind a nude model, a seascape behind a still life, or a backyard fence in juxtaposition with a flower arrangement as in Joan Irving's watercolor, page 69.

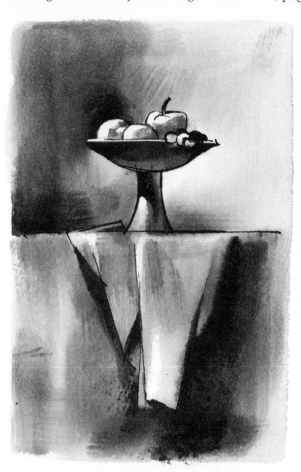

Wet-into-wet sfumato.

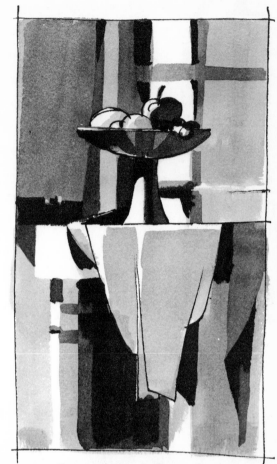

Counterchange in flat washes.

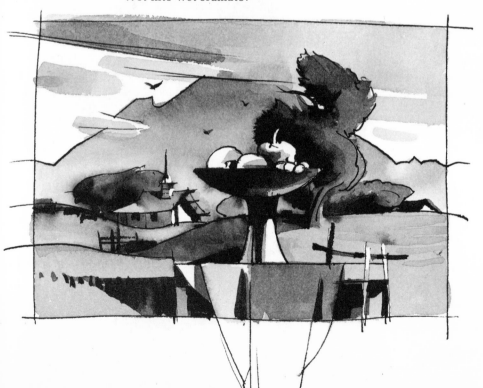

Line drawing based on painting, page 140.

Still life superimposed on landscape.

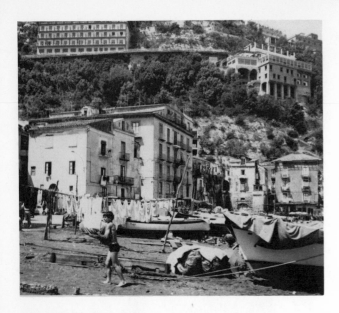

Photograph of the subject.

"LAUNDRY AT MARINA GRANDE"

Boats and laundry stand out in Joan Irving's LAUNDRY AT MARINA GRANDE because she has subordinated the background with a neutral gray wash. Compare the painting with the photograph of the subject to see how much better her relationships of background are to the white foreground shapes as a result of this staging.

LAUNDRY AT MARINA GRANDE, 13½" x 20", Joan Irving

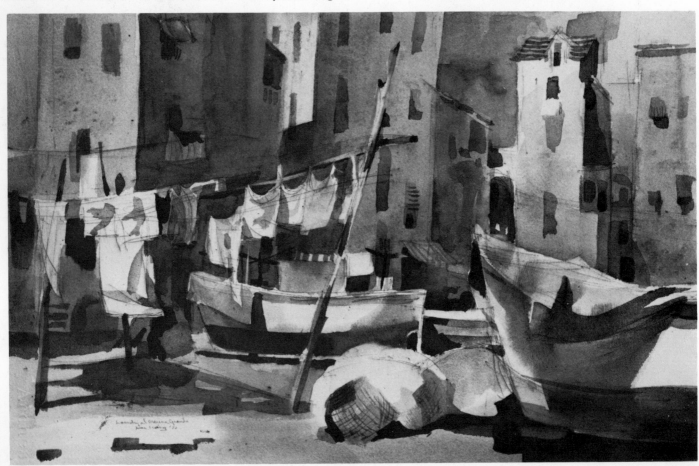

"VIRGINIA CITY NOON"

If we use the sun as a source of pictorial light, we can reduce our design to two interlocking figures as exemplified on these pages. Shapes in sunlight are white or light in value, warm in color; shapes not in sunlight are dark in value, cool in color.

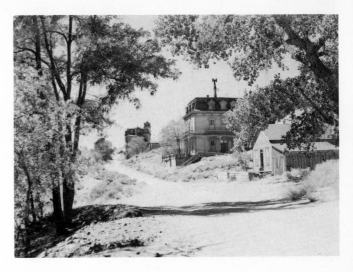

Photograph of the subject.

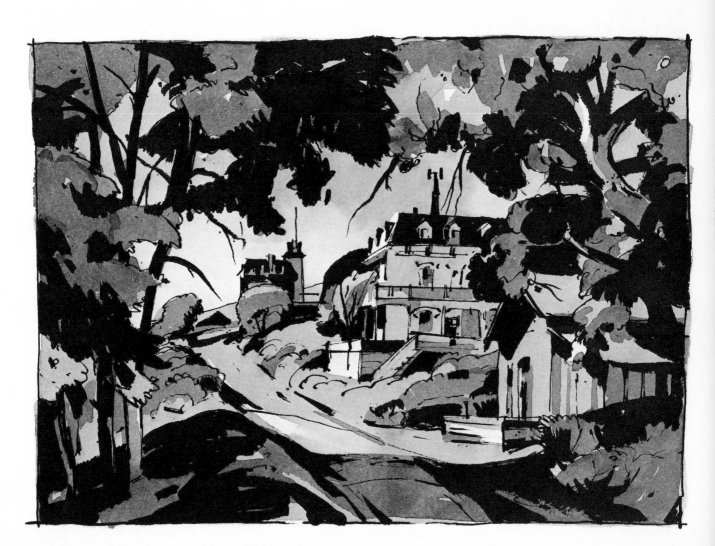

VIRGINIA CITY, NEVADA, 7½″ x 10½″ Monochrome

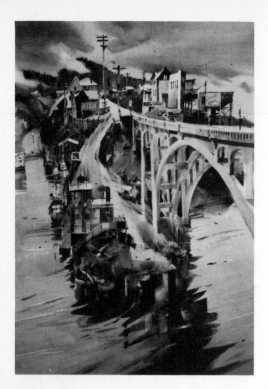

First version

"COAST OF OREGON"

Too many white shapes equal in size and equal in importance contribute to the failure of the first watercolor. (For example, who wants to look at the boldly lighted middle section?)

Before painting the second version I decided that my "first form" was the roadway and rain clouds. Accordingly, they were left white and all else either eliminated or subordinated in a gray wash. The result is a dramatic improvement.

COAST OF OREGON, 29½" x 21½". Collection E. Gene Crain. The Samuel F. B. Morse Medal, National Academy of Design, 1970

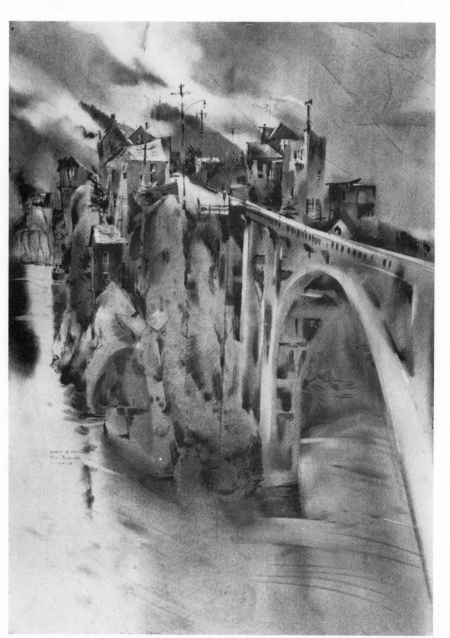

OLD PIER, 20″ x 13½″, Joan Irving

"OLD PIER"

A silvery-gray first wash; then a warm darker gray (Ivory Black plus Burnt Sienna); final accents of rich purple-brown (Cobalt Blue plus Burnt Sienna) — these three steps complete a simple half-sheet watercolor. Note how effectively the artist has employed the rock shapes and shadows to animate the empty foreground and to act as a foil for the pier, its reflections and shadow.

17

RELATING COLOR and VALUE

Hallmark of the beginner is the excessive, tasteless, and pointless use of color. It seems that as soon as one dares to use a full palette, all the disciplines of design are forgotten. This lesson provides clues to the way color may be woven into the structure of white paper and darker paint without destroying the value plan of a composition.

First, I recommend adding color one pigment at a time, always remembering that VALUE is one of the three major properties of color (hue, *value*, intensity). Secondly, ask yourself, "How will this particular color help my painting?" It can help in at least three ways: (1) Creating a mood or tone; (2) establishing a feeling of space and volume; (3) identifying shapes, e.g., the green circle is a tree, the red one is an apple. But seldom will more than two or three colors be needed to do ALL these jobs.

Think of the entire palette as the full piano keyboard. Like the pianist, don't feel obligated to hit every note in every piece. Let feeling (mood) guide you in your selection of color.

You will find that although there are *three* primary hues (red, yellow, and blue), you have jumped into color as soon as any two pigments are brought into juxtaposition. For example, color contrast can be achieved with just Ivory Black and Yellow Ochre. The warmer yellow makes the neutral black seem bluer, and the result is a satisfactory indication of sunlight and cool shade or shadow.

Experiment with this popular pair, and then proceed to add a hint of red by the addition of Burnt Sienna — the "Velasquez" palette, subject of this assignment. Later you may raise the color key by substituting a high-keyed pigment or two as illustrated on the facing page.

Assignment:
Select a composition from your last two lessons. Pencil it in thumbnail size, about six inches wide, and paint in four steps.

Step 1: Plan the whites.

Step 2: Cover the sheet with a light gray wash, holding the whites open. While this is still wet, charge it with bits of color. Ochre for yellow; Ochre and Black to make green. Ochre and Burnt Sienna to make orange; thin Black to make blue. Heighten these color illusions by playing opposites: for example, if the tree is to be yellow (Ochre), make the sky more purple in its appearance by adding Burnt Sienna to the Black.

Step 3: When Step 2 is dry "lock the picture up" with a deeper wash of gray-black, charging in colors with very little extra water. Keep the wash areas alive and colorful by mixing the pigments on the paper wherever possible — not on the palette. Premixed color gets the monotonous look of house paint.

Step 4: When all is dry, study the picture. Turn it upside down. Satisfy yourself as to where the final accents truly belong — they may have to be shifted from the areas you originally planned. Now lay them in, few in number, deep, strong, with little water. Remember that the "smaller the area the richer the color"! You should have a solid, bouncy watercolor.

Materials:
Stretched quarter-sheet. (Will accommodate two or more examples.) Yellow Ochre, Burnt Sienna, Ivory Black (or Payne's Gray).

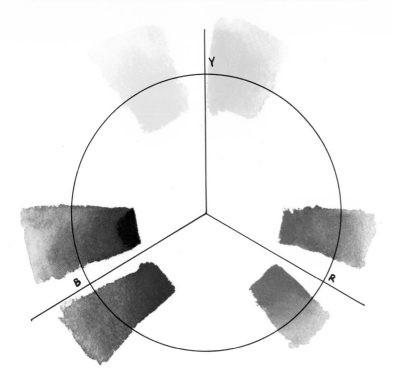

The interval between primary colors is so great as to create a problem in mixing the secondary colors — orange, purple, and green — unless the gap is bridged by two of each primary color as shown. This palette contains Cadmium Yellow Pale, Cadmium Yellow Medium, Cadmium Red Light, Alizarin Crimson, Ultramarine Blue, and Prussian Blue.

A LOW-KEY LIMITED PALETTE

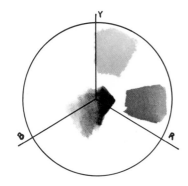

By using any three pigments that form a triangle on the color wheel, it is possible to create an illusion of all color. This is the *Velasquez Palette:* Yellow Ochre, Burnt Sienna, and Ivory Black.

A HIGH-KEY LIMITED PALETTE

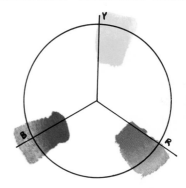

If one doesn't mind a certain muddiness in his secondary mixes (caused by the wide gap mentioned above) he may select only one pigment to represent each primary. In this example are Cadmium Yellow Medium, Alizarin Crimson, and Cobalt Blue.

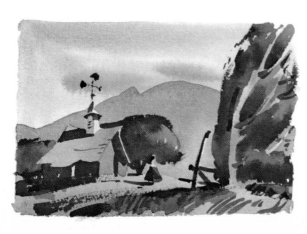

Low-key minimum

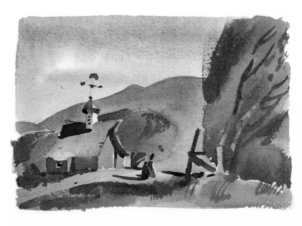

High-key minimum

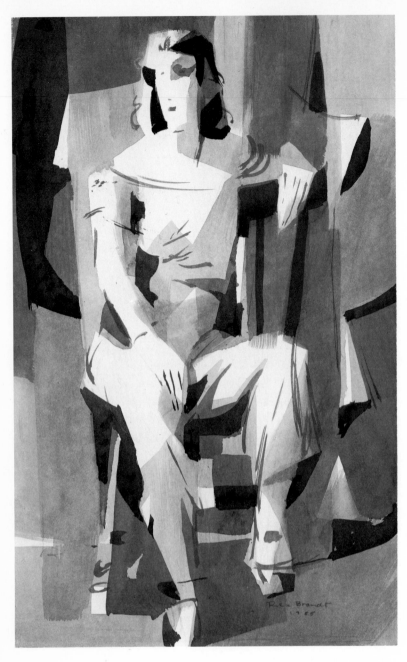

Four-value monochrome wash painting, 18″ x 11″

In the four-value monochrome wash painting above the focal point or "first form" is the light on head and shoulder. This is left white, requiring that dark comes next, and then minor whites and darks "rippling outward" to the margin.

In the painting JOANIE opposite, the gay summer straw hat is the "first form." It is left white, requiring that the next shapes be darker. Also because it appears as a warm yellow color, the adjacent dark is painted a cool green — and the model's brown hair receives a touch of complementary purple-blue (Ultramarine). The dark drawing board is purple in juxtaposition to the yellow hat. The dress turns from light/warm to darker/cool while the background reciprocates, shifting from dark/cool against the lighted side of the figure to lighter/warm against the cool shade side. This is an example of color selection based on sunlight and shadow — the basic warm/cool as perceived in nature.

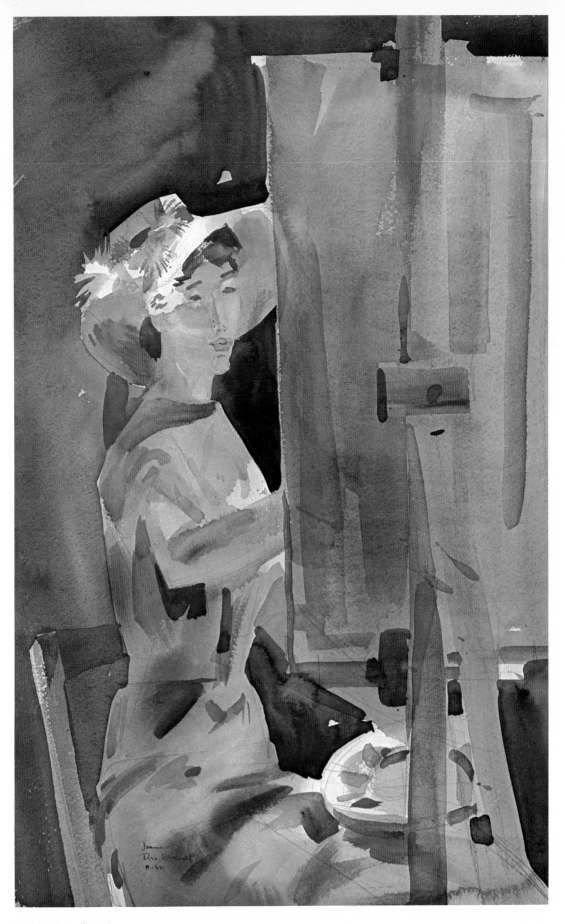

JOANIE, 19″x12″

THE ILLUSION OF LIGHT and its influence on choice of value pattern, color, and technique

What kind of a light do you "throw" on your subject? What kind does the subject "throw" at you? Most beginning painters not only can't answer this question but are not aware that sunlight, firelight, and the subjective human eye create varied modes of illumination — and that each is *readable*.

CONCEPTS BASED ON SUNLIGHT

(1) Backlight: The sunrise-sunset illusion. Emphasis is on silhouette as in Oriental painting. Texture is indicated at the edge of the shape. Color is tonal and subordinated to value. Value range may be intensified by gradation from dark to light. See examples on pages 127-129.

(2) Frontlight: The darling of photographers, who advise "For best color have the sun behind your back and fully on the subject." Color and texture are emphasized. Round objects appear flat. This viewpoint is a favorite of children, primitive artists, and colorists. For example, Van Gogh moved his light from behind the model to behind the artist as he matured — changing from value dominance to color dominance in his later years. The American watercolorist Maurice Prendergast favored front light because he liked color and texture more than shape or value, as did most of the Impressionists. See examples on pages 69, 77, 139, and the Dufy on page 53.

(3) Sidelight: Favored by Western painters from the Renaissance on, this light splits apples, heads, mountains into two parts — a light and a dark side — which creates an illusion of cubical volume. Objects thus segmented seem to relate more easily to other objects. Color is subordinated to light and dark, and is affected by the warm/cools of sun and shade. Texture is most evident at the edges of shapes and at the "core" or median between the lighted and non-lighted facets. A favorite light for the watercolorist because it permits him to assign white paper to approximately one half of the sheet, thus allowing for fewer — and more transparent — darks. See examples on pages 81, 116, 117, 123.

CONCEPTS BASED ON THE PHYSIOLOGY/PSYCHOLOGY OF SIGHT

(4) Reciprocal light: As one becomes more experienced, he will make value and color decisions in terms of the needs of his composition rather than on any one illusion of sunlight. For example, a light orange shape invites a dark shape next to it, while the principles of complementary contrast suggest that it be colored blue. The needs of design — mood, identification, attention, and so on — may modify the color selection further. See examples on pages 138, 152.

(5) Ambiguous light: Color, texture, and value selections are based on the feelings and beliefs of the artist and must therefore be defined by other means than visual phenomena. El Greco's oils and the expressionistic watercolors of Marin, Feininger, and Lewis are examples, pages 5, 70, 71. Other examples are on pages 17, 89-92.

BACKLIGHT

Silhouette: Oriental

FRONT LIGHT

Color and Texture: Primitive, decorative

SIDE LIGHT

Volume and Weight: Renaissance

PICTORIAL LIGHT

Reciprocal and Ambiguous: Most of the painting of the twentieth century

Three paintings failed, perhaps because I tried to paint the scene without a good value plan. Note how wastefully the whites are scattered through each example. Color, likewise, is spotty and uncoordinated.

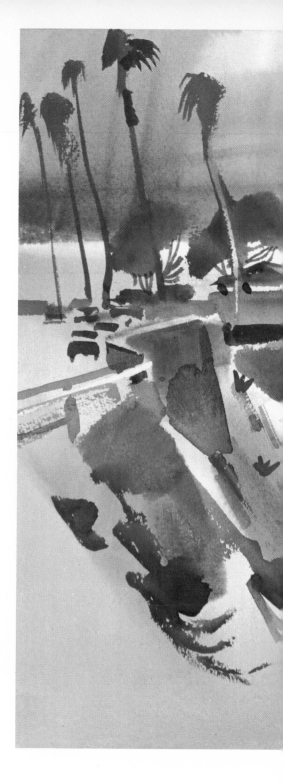

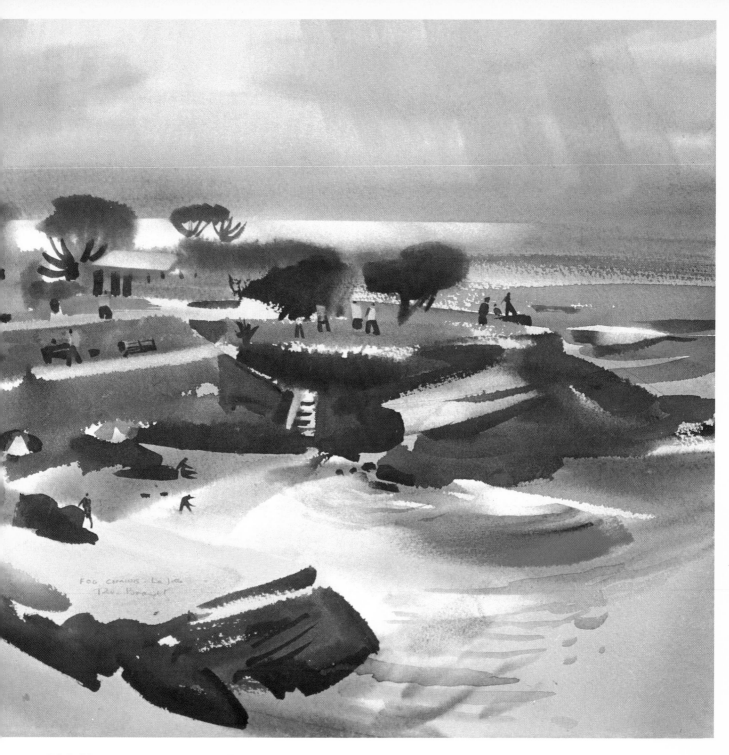

FOG COMING, LA JOLLA, 13½"x20"

Copley Foundation Collection

The fourth attempt is better. Two whites and four colors, of which the Ochre
warmth and Viridian green cool dominate, establish a simple visual hierarchy.
First one looks at the distant sea, then the cove, and finally at the minor parts
of umbrellas, buildings, and so on. The effect is based on backlight.

MOUNT HELIX, 13″ x 19″ Copley Foundation Collection

Two more examples of simplification by the almost Oriental use of backlight or silhouette. Local colors are subordinated to an all-encompassing tone. Texture and much minor detail is eliminated.

MOUNT HELIX above is painted in the low-keyed limited palette (page 121). The drawing was made with a ballpoint pen. First wash, the sky, was handled as wet-into-wet. The other washes are gradated, with a pause for each to dry.

AUGUST DAY opposite is painted in the same palette as above, augmented with Ultramarine Blue and Cadmium Yellow-Orange. The first warm wash was handled wet-into-wet to animate the foreground. The other washes are flat with some wet blending.

Pen sketch of subject, 8″ x 10″

AUGUST DAY — LOPEZ ISLAND, 21″ x 28½″ Collection Helen H. Zillgitt

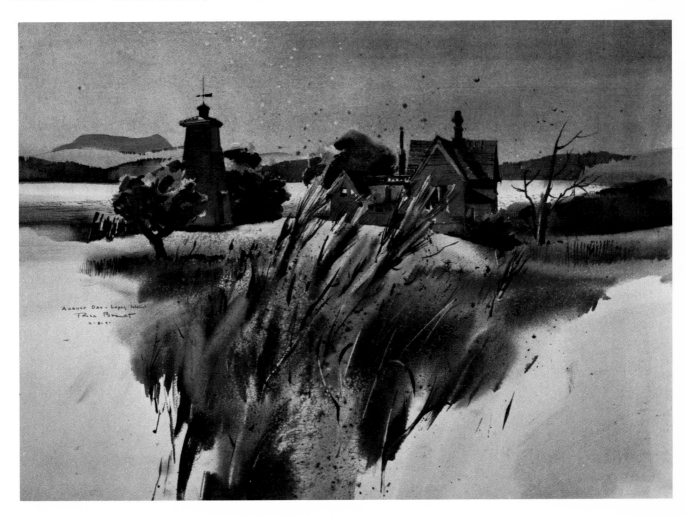

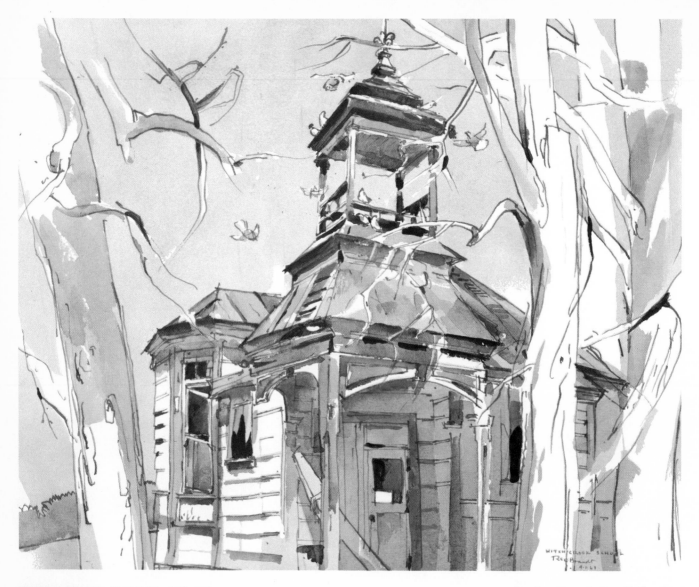

WITCH CREEK SCHOOL, 13"x16" Copley Foundation Collection

"WITCH CREEK SCHOOL"

"Ashes to ashes and dust to dust!" When my San Diego book publisher suggested that I paint the abandoned Witch Creek schoolhouse, I responded with a literal sketch of the decaying old building. But this failed to give me enough background shapes to serve as counterfoils for the values and color of the building; nor did the solitary shape convey the intimate way the surrounding trees and weeds were claiming it as their own. So I tried interweaving the building with the pattern of surrounding eucalyptus trees. This provided nice opportunities for reciprocity, counterchange, and passage.
(Lesson 16)

"TAXCO"

Note how important the *passage* of white is in welding the sky shape to the church shape. If the lights did not flow through the painting, it would be much less effective and the sky would have a completely negative feeling. A sponge was used to create the clouds against the mountains. Observe how much detail is suggested by the varied pigments charged into each wash area, and by the stabs of brush calligraphy.

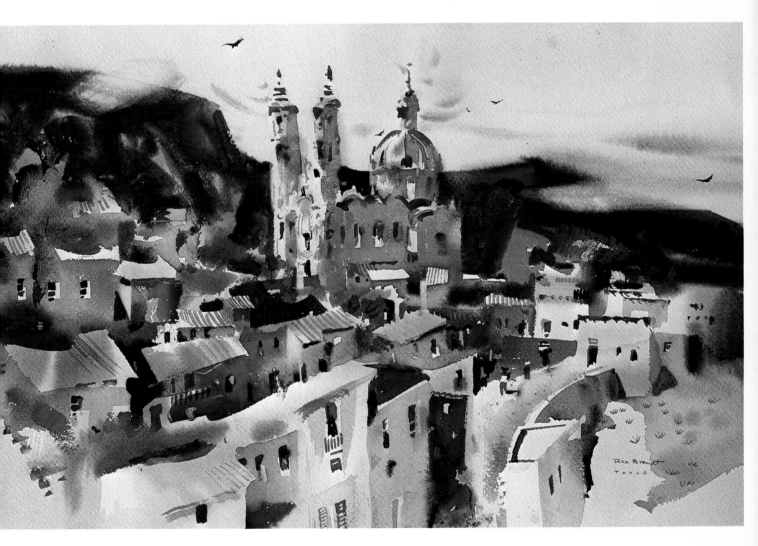

TAXCO, 13½″x20½″

Photograph of subject

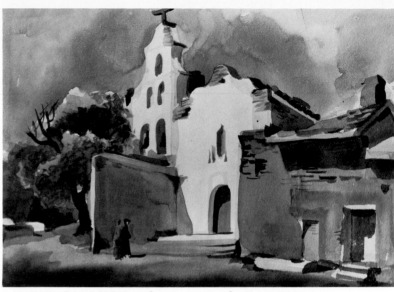

SAN DIEGO MISSION: A demonstration by Dong Kingman

Dong Kingman explained that he wanted to emphasize the doorway and bell tower, rather than the wing hall, so he anticipated the afternoon light and reversed his values from those existing at the hour of this demonstration (see photograph). Note also the arbitrary darkening of the foreground to further dramatize the center of the painting.

George Post demonstrates the creative use of light in his RAMPARTS OF QUEBEC below. He places the sun on his right to light the foreground balustrade, then shifts it to his left for the pattern of buildings at the lower right. And the distance is picked out with a burst of high overhead light, as if from a crack in the clouds.

RAMPARTS OF QUEBEC, George Post

FOOT OF HYDE, 21″ x 29″ For American Airlines Refer to page 11

"FOOT OF HYDE" with its reasonably consistent side lighting is animated by
the persistent drumbeat of value alternation (counterchange).

PAINTING AT NIGHT

A typical procedure for night sketching: Choose a moderately well-lighted street corner or doorway with sufficient illumination to see the paper and yet not blind the eyes to sight of nocturnal subjects. Moisten the sheet and paint the warm lights of windows and doors first. Then, without pausing, paint the darker shade and shadow. Washes dry slowly at night, therefore not too much water. At night, shade and shadow become one, so tie the darks together. A similar procedure for painting interiors.

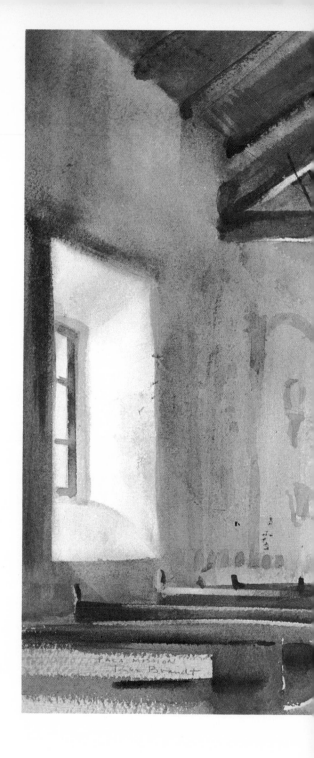

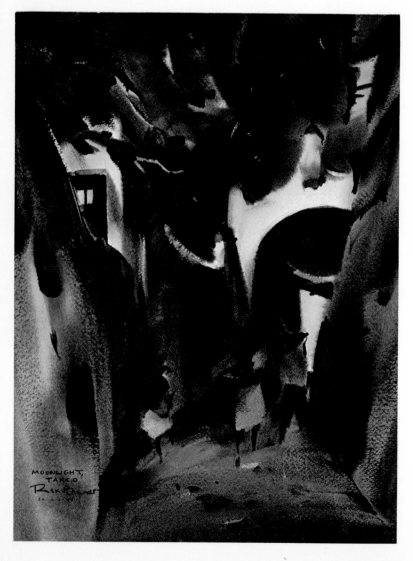

MOONLIGHT, TAXCO, 17½"x13"

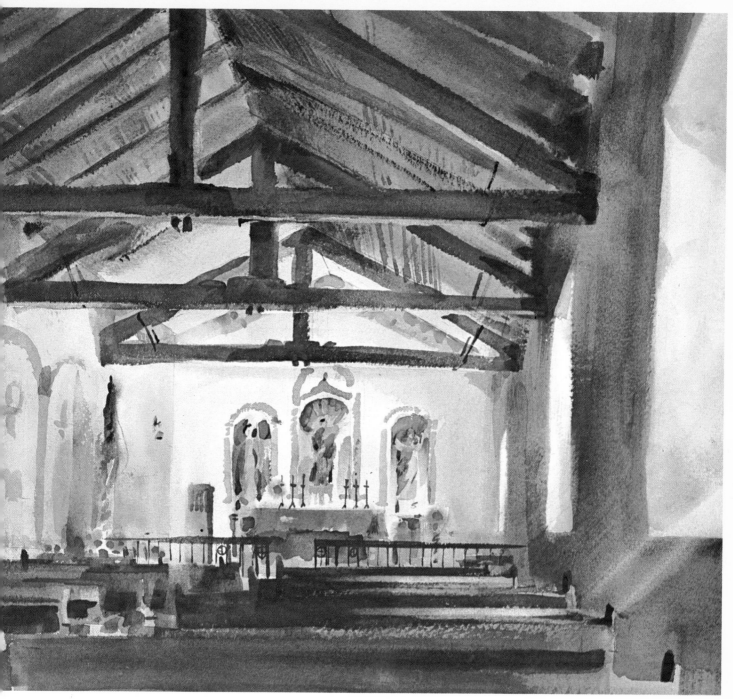

INTERIOR, PALA MISSION, 13½″x20″ Copley Foundation Collection

THE EFFECTS OF SUBDUED LIGHTING

Explore the unique and special ways of visible light as experienced at night or in an interior and you will discover that restricted lighting offers exotic variations to otherwise mundane subjects. I describe it as the mood of "goblins and ghosts."

18 CREATIVE CALLIGRAPHY

What's your line?

As decorative and distinctive as are the linear patterns of such Western watercolorists as Raoul Dufy, Charles Burchfield, John Marin, Mark Tobey, and Paul Klee, it is the Oriental watercolorist who seems to preempt the art of calligraphy. Yet the Western world admires individuality and is invariably intrigued by expressive handwriting. I think it is time for American painters to do something about it. This assignment demonstrates a way by which your brush line may be refined to develop such an iconography.

Assignment:

Sketch the subject, laying it in with pencil first if necessary, then painting lines and textures with a pointed, round sable brush and black paint.

Once the drawing is dry, try another by pressing a second sheet over the first, firmly enough to reveal the pattern through the paper. Then, using only the brush, try to improve on the first version by simplifying and strengthening. When this one is dry, add a third sheet and try again. Continue in the same manner until you are completely satisfied.

The example on the facing page is the sixth overlay, based on the sketch below. With each successive study, I moved the overlying sheet about as I worked, selecting the parts to be strengthened and eliminating or shortening those sections which seemed irrelevant.

Materials:

A soft, semi-transparent Oriental paper such as Hosho, six sheets or more, and Ivory Black paint.

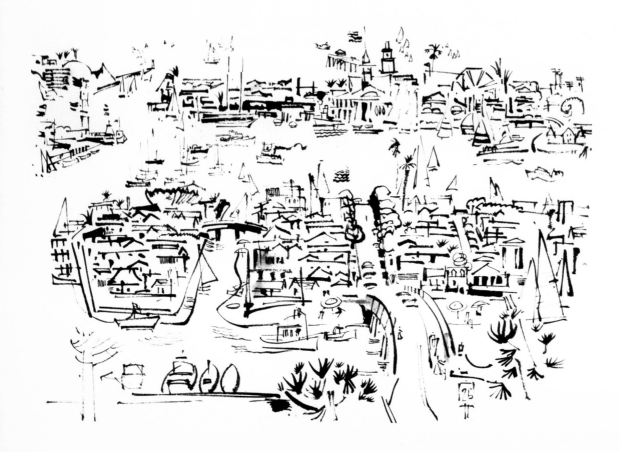

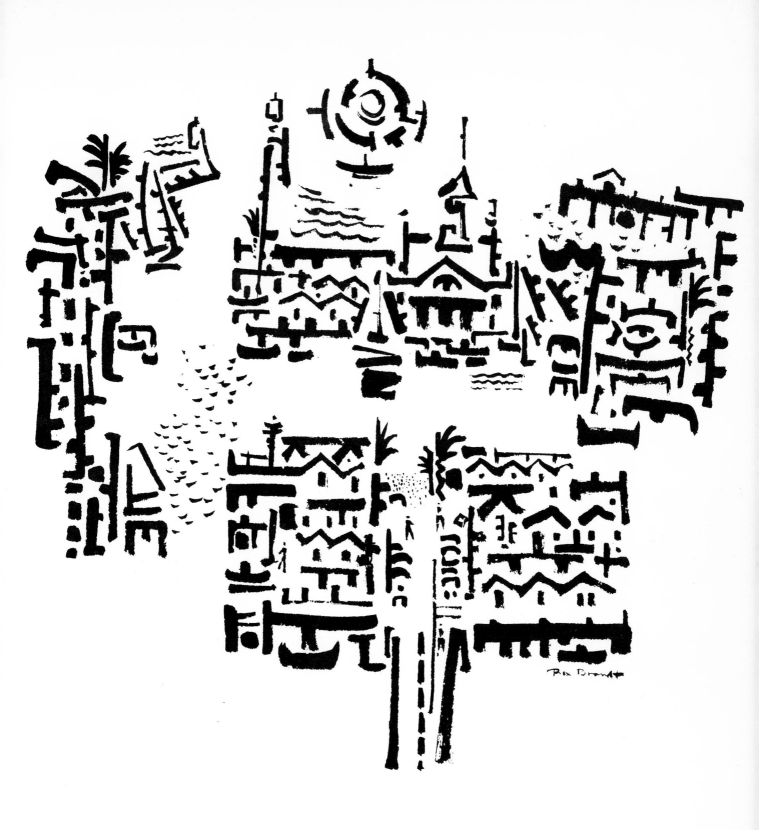

BAY, 17½″ x 18″ Brushline on Hosho paper

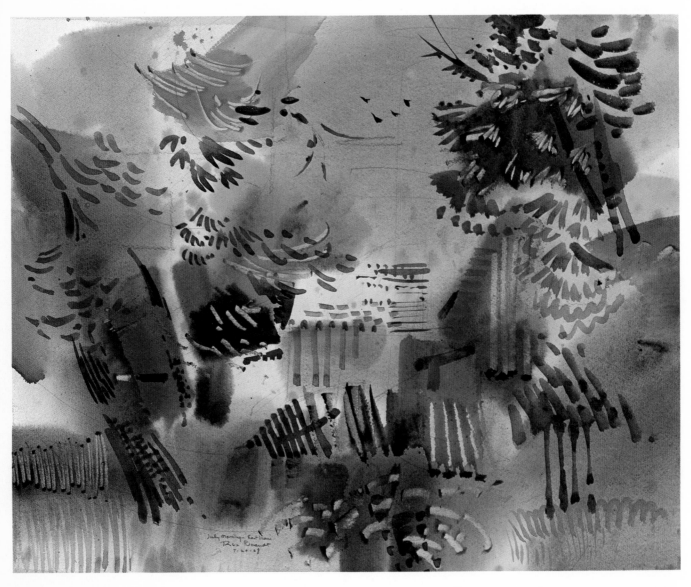

JULY MORNING, EAST IRVINE, 13½"x17½" Collection Dr. and Mrs. Victor J. Westover

Calligraphic textures scraped into wet color with brush handle.

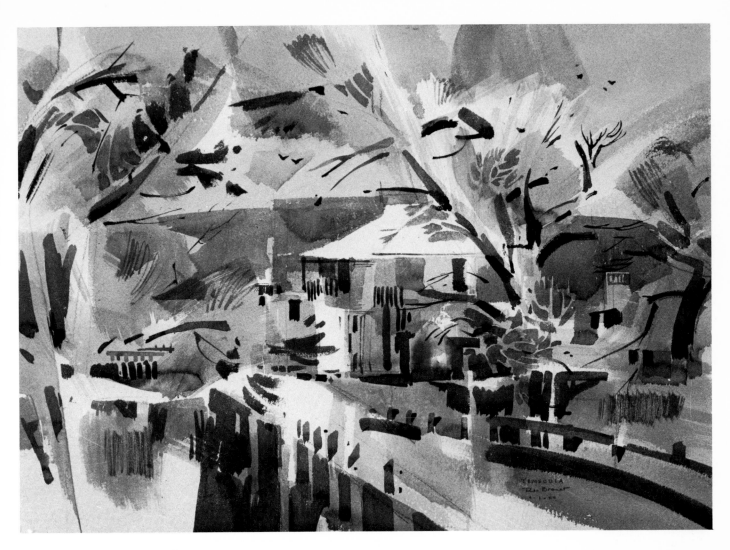

TEMECULA, 22″ x 30″

Brush line strokes and textures over wash shapes.

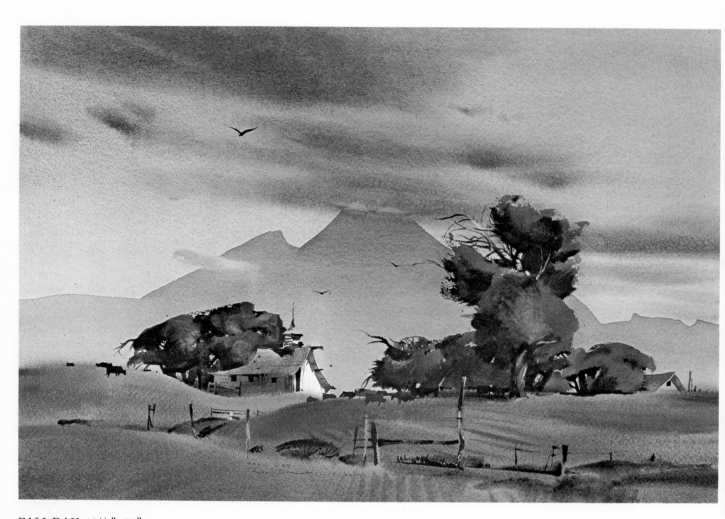

FALL DAY, 13½″x20″

TREES and FOLIAGE

No subject is more challenging or more intriguing than the translation of foliage and tree shapes into the language of paint.

If you try to paint all the leaves you will have a tedious and heavy form. If you model the entire foliage structure as though it were a tennis ball, you will miss the airy sense of a habitat wherein birds nest and children climb.

To avoid a ponderous, unporous effect, think of the tree in the same way you would consider a cloudy sky — a series of vaporous, overlapping curtains of foliage, as analyzed in the accompanying diagram.

To better understand this, make a spatial analysis of a tree with pen or pencil using the "playing card" treatment, that is, simplify its parts to geometric shapes that overlap each other. Diagram 1, which analyzes the eucalyptus tree in the watercolor opposite, is an example.

Once you are certain that you have established the correct spatial relationships and proportions, duplicate the diagram but with open shapes (2). The result will be more tree-like without losing the sense of space.

Addition of an informal, texturally-inspired line heightens the impression of foliage without a loss of mass (3).

1

2

3

SOME USEFUL OBSERVATIONS

(1) Each tree form has a characteristic silhouette. The bulk of the weight is through the middle; the sky holes are to the outside edges. Trunks taper into limbs, and limbs into branches and twigs.

(2) A tree is three dimensional — not flat; its branches spread to each side. And in addition, they come toward you — and move away.

(3) Space is more important than texture (leaves). Texture may be suggested where it is seen. Study the photograph of the moon on the facing page. It has texture. Where do you notice it? It is most evident where dark meets light and around the edges.

 To duplicate the moon's surface, I would use a well-loaded brush and drag the heel as shown. The roughness of the paper will give it texture. The same would apply to the tree paintings. I might add a few flecks of leaf with the brush-tip at the edges and where dark and light meet.

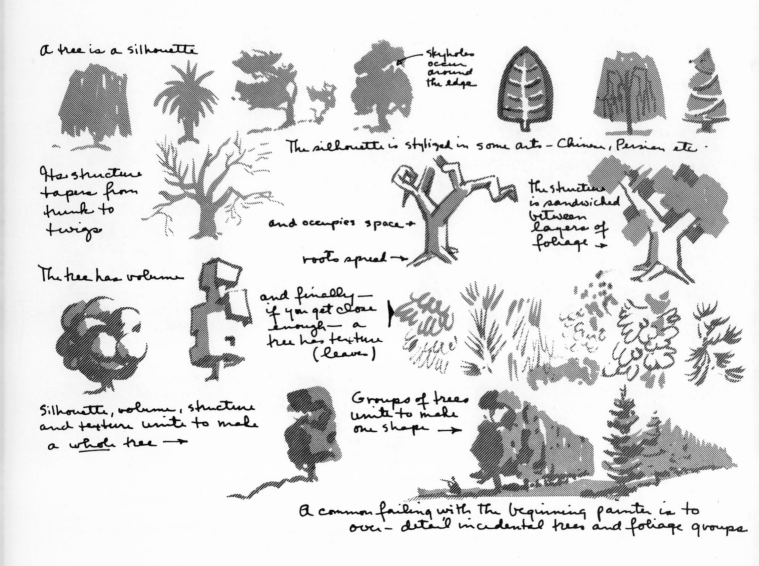

A tree is a silhouette

skyholes occur around the edge

The silhouette is stylized in some arts — Chinese, Persian etc.

Its structure tapers from trunk to twigs

and occupies space →

roots spread →

The structure is sandwiched between layers of foliage →

The tree has volume

and finally — if you get close enough — a tree has texture (leaves)

Silhouette, volume, structure and texture unite to make a whole tree →

Groups of trees unite to make one shape →

A common failing with the beginning painter is to over-detail incidental trees and foliage groups

Assignment:

Complete four or more silhouettes of trees in middle gray — look for a variety of tree types. When the silhouettes are dry, load the brush with black and paint the shade and shadow sides, darkness around sky holes, twigs and limbs in shade. Work for texture at the meeting point of the light and dark.

Materials:

Rough watercolor paper. No. 10 brush. Ivory Black.

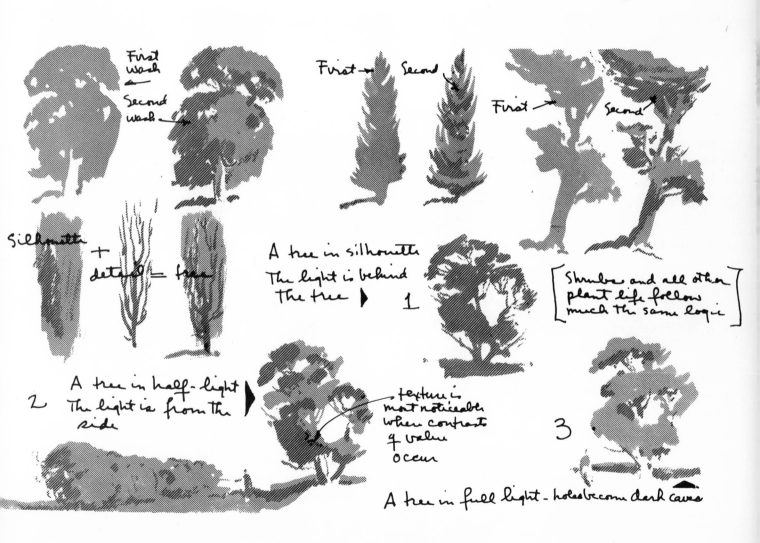

First wash

Second wash

First → Second

First → Second

Silhouette + detail = tree

A tree in silhouette. The light is behind the tree ▶ 1

Shrubs and all other plant life follow much the same logic

2 A tree in half-light. The light is from the side ▶

texture is most noticeable when contrast of value occurs

3

A tree in full light — holes become dark caves

143

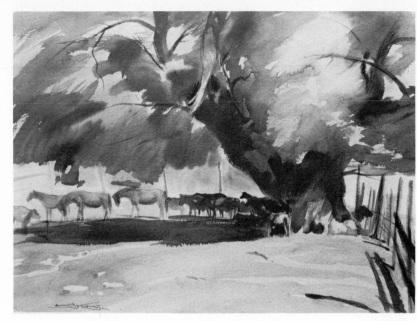

SUMMER TIME, 22″ x 30″, Emil Kosa Jr.

OAK TREE SHADE, 20″ x 28″

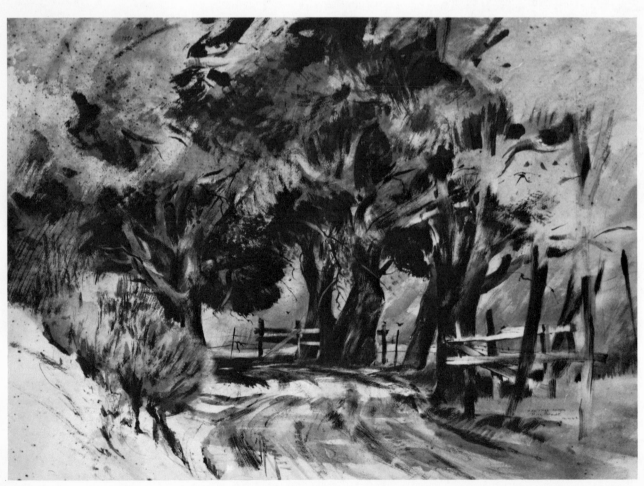

20

THE TECHNIQUES IN COMBINATION

Three basic techniques in watercolor have been· studied at this point; the wash or control method, wet-into-wet, and drybrush and line.

Which of the methods is the best? The problem and the individual's temperament and taste will dictate his choice. All three may have a place in the same painting.

(1) Brush line has an almost primitive directness. It is quick, descriptive, epigrammatic, and decorative, but it tends to be thin and does not carry far visually. Drybrush alone glitters.

(2) Wash is the most positive means of indicating shape; if shapes are the language of art, then wash is fundamental. Its strength lies in its simplicity; its weakness can be monotony.

(3) Wet-into-wet is freest and most spontaneous, for it must be executed quickly and confidently. Its explosive character is its charm; difficulty of control and vagueness of shape, its weakness.

When combined, the three techniques provide a range of textural contrasts that greatly increase the legibility of a painting and overcome the limitation inherent in each technique.

Operationally, if you have adopted the four-value sequence for painting as presented in Lessons 11 through 16, a mix of techniques is quite easy:

(1) After planning for the whites, then the rest of the sheet is painted a light gray. Local color may be introduced into this wash while it is still wet and all soft-edged shapes, such as clouds, are completed.

(2) Next, the dark pattern of shade and shadow is painted as a flat or gradated wash, serving to set up the lights and group the darks. The edge of this wash may be knife-hard to represent a water surface, or dragged drybrush-style to suggest a roughness of weeds.

(3) Finally, the darks are located and painted either as wash or drybrush.

Assignment:
Try two or more compositions — such as the ones completed for Lesson 13 — using the several techniques in the sequence listed above. Examples are on pages 36, 72, 140, and 149.

Materials:
Two or more stretched quarter sheets; full palette.

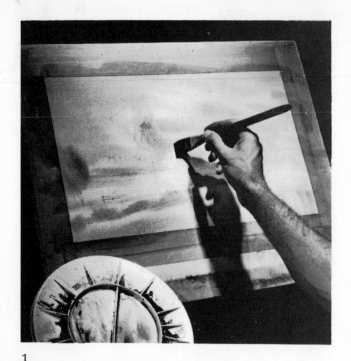

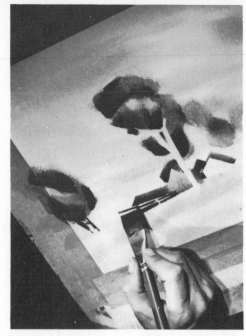

1

2

THE COMBINED TECHNIQUES DEMONSTRATED

(The subject is similar to the landscape on page 140.)

(1) Wet-into-wet underpainting: All the soft-edged objects, such as the sky and the undertone of fields and road, are worked into the sheet.

(2) When the sheet is dry, the center of interest is developed, but with a large brush to avoid any temptation to "worry" it.

(3) Silhouettes of trees are enriched with brush line branches.

(4) To lighten the value of the sky, several dark bird symbols are placed over the original wet-into-wet and the watercolor is ready to be tested in a mat.

Reminders:
Use a minimum of drawing with the pencil so that you may design as you go. The objective is a painting — not a colored drawing.

Pre-moisten the sheet for several minutes *before* commencing wet-into-wet; it will stay wet longer. But remember to sponge up any surplus water that otherwise might be drawn back into the drying surface.

Keep the board nearly horizontal and the brush handle well up, except when doing drybrush scumble.

Avoid niggling, ropey-looking shapes by using large flat brushes as much as possible.

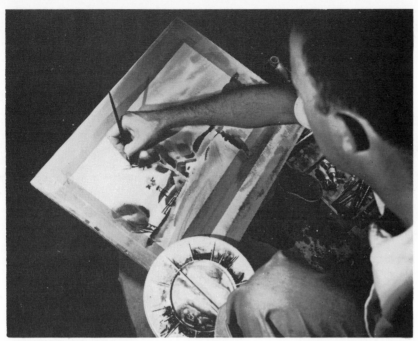

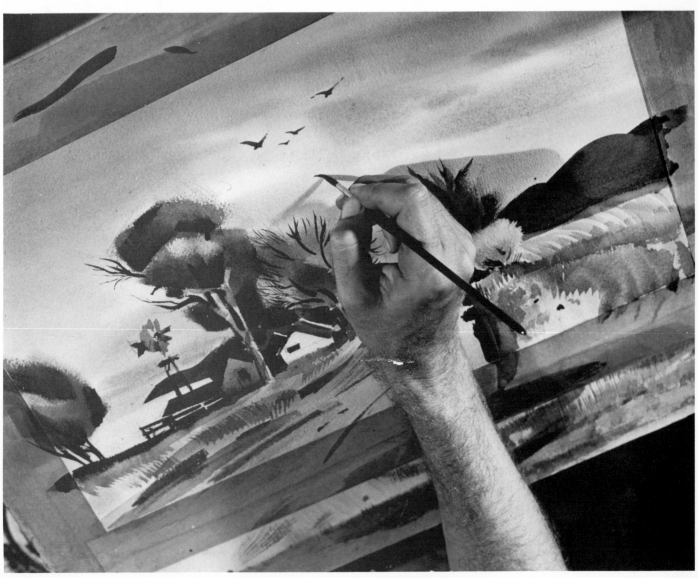

SUMMARY OF TECHNIQUES AND USES

	To represent	To create	Examples
FLAT WASH	Solid, geometric shapes, decorative areas, hard-edged objects	Mass, power, weight; stolid, enduring, quiet	Renaissance masters, contemporary posters and illustrations
GRADED WASH	Light and distance, hard-edged objects, movement and brilliance	Movement and vigor; graceful, suggestive, aspiring and spiritual	Oriental painting and Japanese prints
WET-INTO-WET	Soft-edged objects, glow of light, undertones and mood	Organic, vital, expansive, churning and animate, opulent	George Grosz, Western American watercolorists
DRYBRUSH	Heavy and rough shapes, great mass and weight, controlled modeling	Firm, porous, granular, noisy and dissonant, heavy	Constable, Burchfield and many contemporary illustrators
BRUSH LINE	Textural qualities, lines of power and motion	Rhythmic, fluid, dynamic and personal, thin and suggestive, tense and cryptic	Oriental painting and writing

Remember to use the largest brush possible and to stand back frequently.

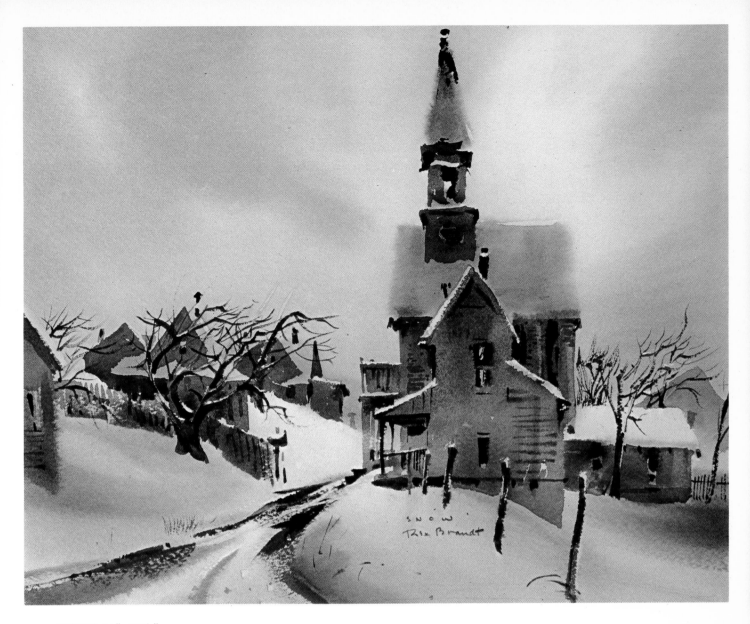

SNOW, 11″x13½″

WINTER SUBJECT IN THE COMBINED TECHNIQUE

Snow reflects a great deal of color, and is normally very soft-edged. Accordingly, I paint it first in the wet-into-wet technique, stroking color right through the areas of future dark buildings. Note the changes of hue on the snow, warm in sunlight and cool for the shade surface of the church roof.

I wait until the first step is dry before painting the shapes of buildings in charged washes so that their hard edges make a nice contrast with the soft snow. Drybrush is dragged over the areas of rutted roadway. The final step is the brush-line patterns of wintertime trees.

HOUSE AMONG THE TREES, Paul Cézanne Collection The Museum of Modern Art

CEZANNE, THE MASTER

Translucent stepped glazes, gentle wedgings of color, glissandos from green
to blue to violet — but, withal, a sense of the white paper — these characterize
the watercolors of Cézanne. No wonder that Picasso, Marin, and most con-
temporary painters call him "master."

As you grow, you will look for new horizons and search for new prototypes.
I suggest that the search start here.

TOWARDS MORE EXCITING WATERCOLOR:

GRADATION

The sparkle of white paper against the foil of transparent, colorful darks is the **charm** of watercolor, but its **excitement** is a product of the unique potential for gradation. No other medium so easily accommodates interchanges of color, arpeggios of value, and fluid oscillations of both color and value.

How does gradation contribute to visual excitement? Here are at least three answers:

(1) Gradation of either color or value modifies the thrust of shape against shape, creating a sense of *warping or tilting*. This, in turn, heightens the plastic or "push-pull" effect as is so well illustrated in the watercolors of Cézanne. (Facing page.)

(2) *Movement across* the shape is accelerated as value or color changes. For example, study the progression from Ultramarine Blue to Yellow Ochre at the right side of the example on page 17 — or the change from dark to light of the washes in the illustration on page 128.

(3) Color and textural variety can be charged into a moist area to create a visual vibrato without violating the readability of the shape as a unit. For example, colors and textures crescendo from near fields to distant trees (page 140) without destroying shape, because they fuse nicely within the wet surface.

To appreciate the potentials of transparent watercolor, study the Masters. Here are some whose works you should know:

For plasticity — the warping, tilting effect — Cézanne, Feininger (page 70), John Marin (page 5), Charles Demuth, and the Chinese landscape painters from the fourteenth century.

For movement across shapes — the Japanese landscape artists; J. M. W. Turner and W. Russell Flint, the Englishmen; and most of the French and German Expressionists.

For modulation and pulsation — Paul Klee, John Singer Sargent, and Raoul Dufy.

SCHOOL PATIO, 19½″x26″

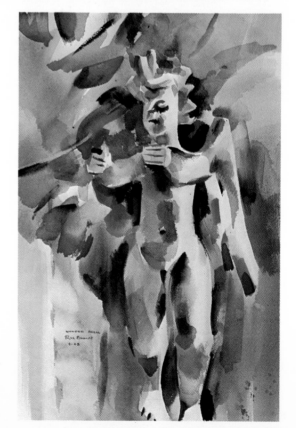

WOODEN ANGEL, 20″x13″

A WORD ABOUT SUBJECT MATTER

What you choose to paint and how you say it are personal matters — but, whatever the subject, you will discover new shapes, colors, configurations, and passages as you work. This enlightening experience is the greatest reward of painting. There is a therapy to be found in the pleasures of seeing, which can enrich your daily life if you involve your home and neighborhood as subjects. And, of course, there is a far greater likelihood that you will find understanding and feeling in such subjects rather than in the exotic and foreign.

Andrew Wyeth painted his farm, Winslow Homer chose the coastline where he lived, as did John Marin; Turner painted the view across the Thames from his studio window. I suspect that propinquity had much to do with these choices — the score reads in favor of the familiar rather than the exotic.

The examples on these pages are motivated by such assorted concerns as pattern, color, and, in the third case, commercial necessity — but because they are involved with my home and studio, they have extra meaning and pleasure for me.

"School Patio." My wife, Joan Irving, walked by as I started the painting and so provided a focal point for a very informal composition. I call this my "rag rug" style.

"Wooden Angel" is a carved wooden Mexican figure, which hangs in Joan's studio. I placed it in the sunlight under one of the rubber trees, and then tried to see how many colors I could find in sun and shadow . . . obviously inspired by Cézanne.

"The Bay from Blue Sky" is painted in a Vandyke Brown and Ivory Black. It is a free interpretation of the view from our house (see pages 88-89 for another concept) to be used as a cover decoration for our Summer Workshop folder. An effort was made to sum up the pleasures of watercolor and the outdoors.

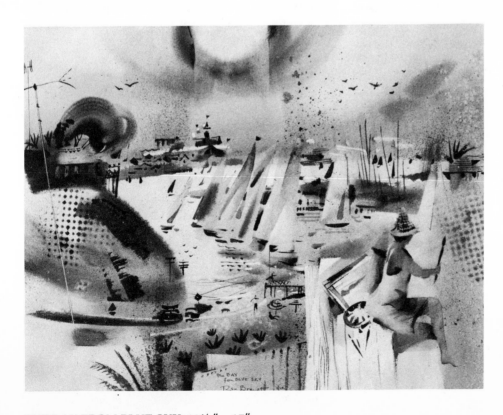

THE BAY FROM BLUE SKY, 13½″ x 17″

PRESENTATION: Mat and Frame

THE MAT

A picture isn't finished until it is matted and ready to be hung. The big moment in watercolor comes when one stands back and takes the first look at one's completed work. It looks different once it is isolated from the brown board and tape stretch. The darks which straggled off the edge of the work now cut firmly against the mat — reminding us that mat and frame are as important to design as are elements inside the picture.

The following pages outline basic procedures for matting and framing. Review them before beginning your first trial mat. Don't leave it to someone else. Check for trim, proportion, color, and value of mat, and use of liner or line. Title your works, and mount them with hinged chipboard backs.

Sign the work with brush or pencil. Take care to locate your signature with taste, and avoid having it "steal" from the picture.

Measure the finished job against the best you can find. How does it look?

HOW TO MAT YOUR PICTURE

(1) Using four strips of cardboard, try the picture for trim. You may find it desirable to cut off unnecessary foreground or sky areas.

Get the optical center of the picture near the optical center of the mat. This center is low in some pictures and high in others — but generally it is above the true center, about three-fifths of the total height.

Compare the two examples on this page that illustrate the extremes in optical heights. The high optical center of the bridge painting requires that the picture be lowered on the mat as far as possible. In the second painting attention is brought to the boats by raising the picture; the gray mat emphasizes the light in the picture.

The bottom example is a good combination: A white inner mat or liner, and a gray or linen-covered outer mat.

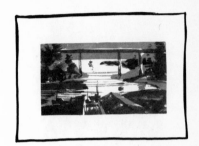

(2) See that hands and table surface are clean.

(3) Cut the outside dimensions of the mat first. These should be standard sizes where possible; typical are 20 x 26, 22 x 28, 22 x 30, or 24 x 30. For full sheets the most popular size is 28 x 36. Generally the smaller the picture the greater the relative size of the mat, and vice versa. Also, the frame affects the size: The heavier the frame, the narrower the mat.

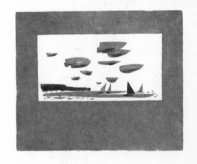

(4) Lightly pencil dimensions of aperture and then cut with a sharp, short-bladed knife. Some use a metal straightedge. I cut freehand, drawing the blade directly toward me as shown on the facing page.

(5) Mat edges may be sanded with fine sandpaper. Pencil lines should be erased with care to avoid tearing paper surfacing.

(6) Tab picture into mat with butcher tape — not cellophane or Scotch tapes as these fatigue.

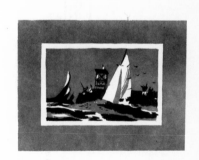

(7) A hinged back, such as the one illustrated opposite, will protect the picture and give added stiffness to the presentation.

THE FRAME

Some of the loss of luster that occurs when the watercolor dries is recovered when the painting is presented under glass. This requires some sort of frame or hanger to support it.

Typical framing methods, arranged from the most economical to the most elaborate:

(1) Free sheet of glass, held to the wall by eye hooks, nails or small pieces of molding. Patented holders are available that will adjust to the size of the mat and glass, and in turn will fix to the wall.

(2) Glass or plastic sheet (plexiglas or lucite) bound to the mat with a cardboard back. Use of a Scotch tape binder in black or color will seal the three pieces together. This may be hung, if not too large, by the use of Dennison's gummed hanger eyes.

(3) Strip moulding, usually not over ¾-inch wide with a fairly wide mat. Most watercolors are presented in this fashion. The disadvantage lies in the large area of glass and the relatively inadequate weight of the moulding. The mat may be cloth covered, doubled, or lined to give an added feeling of depth.

(4) Heavy moulding and narrow mat. This economizes on glass size — makes the frame the mat. The frame may be carved or otherwise finished to harmonize with the painting. The trend seems to be in this direction.

Use of old frames, metal frames, and unusual shapes is seen in many exhibits. Plastic sheets are taking the place of glass. We will do well to continue searching and experimenting to find the best frame for our needs.

Metal and cloth as frame or mat finishes offer textural and spatial contrasts to the watercolor surface. Linen, corduroy, silk, gold leaf, wire screen — an endless variety of materials invites experimentation.

(1) **Glass:** Single strength, Class "B."

(2) **Mat and Painting:** Must not fit too tightly, as moisture may buckle it.

(3) All-rag content **isolation sheet** to keep the acids of the cardboard from staining or embrittling the watercolor paper.

(4) **Cardboard Backing:** Corrugated board preferred, as it will absorb shock.